CUTLER ANDERSON ARCHITECTS

ROCKPORT

CUTLER ANDERSON ARCHITECTS

Sheri Olson

GLOUCESTER MASSACHUSETTS

ROCKPORT PUBLISHERS

First published in the United States of America by

Rockport Publishers, Inc.

33 Commercial Street

Gloucester, Massachusetts 01930-5089

Telephone: (978) 282-9590

Fax: (978) 283-2742

www.rockpub.com

Library of Congress Cataloging-in-Publication Data

Olson, Sheri, [date]

 Cutler Anderson Architects / Sheri Olson.

 p. cm.

 ISBN 1-59253-016-8 (pbk.)

 1. Cutler Anderson Architects (Firm)—Catalogs. 2. Architecture—United States—20th century—Catalogs. I. Title.

 NA737.C88A4 2004

 720'.92'2—dc22

 2003019319

 CIP

ISBN 1-59253-016-8

10 9 8 7 6 5 4 3 2 1

Design: Leigh Mantoni Stewart

Cover Image: Art Grice, Photographer

Printed in Singapore

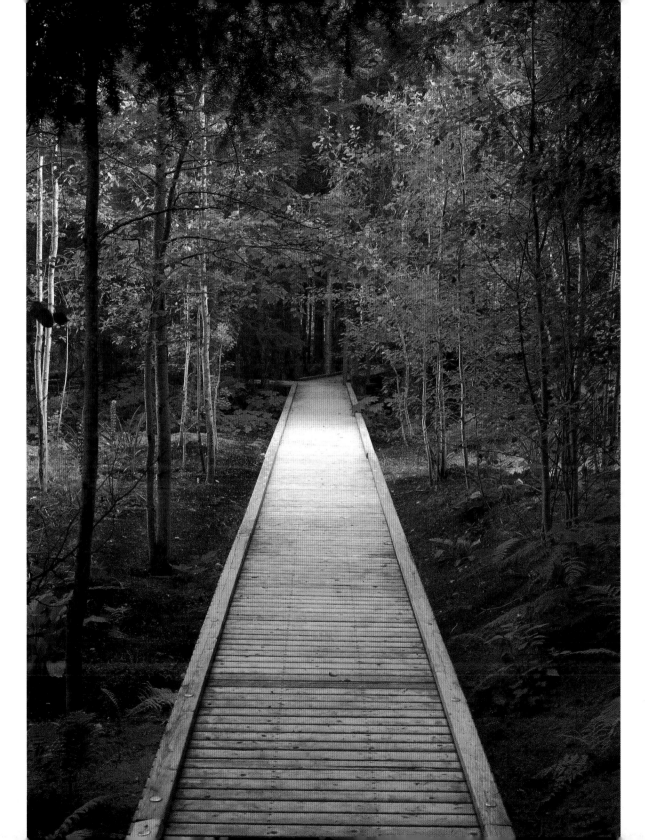

// CONTENTS

Cutler Anderson Architects:

Principals James Cutler, FAIA,
 Bruce Anderson, AIA

Associates Pat Munter, AIA
 Janet Longenecker, AIA

Foreword :
The Case for a Tangible Reality

Sitting on the upper deck of the ferry that travels from my Bainbridge Island home to Seattle, I ponder the future of architecture and wonder if architects have lost touch with core values. It's an unusually sunny day in late December, and a fiddler plays in the corner of the sheltered area while high-pitched children's voices mingle with the low pitch of adults in quiet conversation. The ferry engine hums steadily in the background, and the hull pushes aside the water with a gentle sound. The low winter sun sparkles silver off the water, and the dark north face of Mount Rainier, 60 miles away, looms over this picture, reminding us of our position in the landscape. What does this delightful scene have to do with architecture? Everything. I feel architects can capture and illuminate these moments of visual and acoustic pleasure that elicit emotional and memorable responses.

I often find myself surprised and moved by a photographer's ability to capture moments of beauty that might, at first glance, appear mundane or go unnoticed. A stick on the beach or a pattern of stones can be transformed by the way a photograph reveals the subject's essence. Architecture can also reflect and reveal the unique characteristics of materials and places. By beginning with the assumption that everything—from objects to people and events to institutions—has a nature or spirit, architecture can reveal that spirit in a way that is as tangible as this pleasant winter scene.

From the Seattle ferry terminal, I meander up to Pike Place Public Market. This conglomeration of nineteenth- and early-twentieth-century buildings forms a vertical edge between downtown and the waterfront. I buy fresh bread, Spanish cheese, and a little basket of out-of-season raspberries and sit on a bench in the main arcade. Cold air permeates the market but has not deterred the weekend crowds of shoppers, tourists, musicians, and fishmongers, all enjoying this urban show. Like many people, I love the market. It is a tangible conduit for people to connect emotionally with the city and the region. It also elevates the everyday experience of shopping and more truly reveals the actual social nature of "market." The directness of the experience—the barter and banter with merchants and craftspeople, the careful arrangement of produce and crafts, the presence of crowds of shoppers—connects us to the fundamental essence of the institution of "commerce." The experience is genuine, and we respond to it in a way not matched by the automated checkout at the supermarket.

This example of an institution revealing its true nature and, thus, creating an emotional and memorable response is more than applicable to our profession. It is not clear to me that we, as a profession, see or value this. It is difficult to listen to the voices of every social and material component of a circumstance and produce a design that allows them to sing in harmony. It is much easier to pick up on a narrowly focused topical abstraction or a technological marvel and run with it, ignoring the tangible realities of region, place, materials, and even institutions.

I'm home now. The weather has turned. The wind is howling through the fir trees on the edge of my bluff. The gusts

carry with them a horizontal rain that is pelting the windows. This rain and wind have gathered their energy far out in the North Pacific and are expending it against my trees and house. Immense thermal forces generated thousands of miles from here are knocking on my windows to remind me that the small place I live is connected to the whole planet and is subject to its forces.

Inside, it's calm. The cats are sleeping on their respective turfs. There's a low fire in the ill-scaled stone fireplace. In the bookshelves above the fireplace is a book entitled *Life*. The author, Richard Fortey, who was chief paleontologist of the British Museum, traces in a mere four hundred pages the history of life for the past two billion years! This synopsis of the broad sweep of evolution concludes with a photo of rows and rows of slot machines. The photo is used to illustrate that we are the product of a million times a million almost random chances, possibly more chances than the number of stars in our galaxy. Fortey makes it clear we were not inevitable. At each chance occurrence in

the history of life, things could easily have gone a different way. Given the enormous compounded number of events that created us, it is probable that we are unique in the universe. There almost certainly is other life out there, but something that sees, perceives, and feels the world around it in the way we do is highly unlikely. For all we know, we may be the only living thing in the universe that feels emotion or sees beauty. Our rational and emotional cognition of the world around us is what makes us human. It is a gift beyond measure.

Given this singular ability, I would argue that responding to, revealing, reflecting, and protecting the uniqueness of the real world around us should be our highest calling. Choreographing the visual experience of individuals so the most poignant "photos" of a particular set of circumstances are revealed gives viewers the opportunity to understand the world around them, not only on an intellectual but on the more important emotional human level. These emotional responses connect us strongly to the world, and in this memorable way, they open the doors for us to feel and love—in essence, they remind us of the gift of cognition.

In a world in which the sheer pressure of human population growth is devouring our biodiversity and changing our atmospheric chemistry to the point of radically altering our climate, there may be great

value in employing an ethic that guides people to an emotional connection to reality. I know of no one who is in favor of these ongoing environmental alterations or is looking forward to the unpredictable consequences. I also know of no one who feels the planet will be a better place to live two hundred years from now. Yet, why do we do little or nothing about changing this potentially unpleasant future?

Even though the answers to this question may be politically complex, I feel the core of the problem lies in our fundamental disconnection from the living world that sustains us. We, as a culture, no longer have the primitive emotional knowledge that we and the rest of the living world are one. We may not be able to do anything about this loss and its concomitant problems, but if there is a path that avoids the looming future, it will start from an ethic of respect, appreciation, and love for all the variety of this planet. That love can only be fostered by first promoting an emotional connection to the world. Where our hearts go, our minds and actions will follow.

Therefore, I feel any methodology in any craft or profession that reinforces an emotional recognition of the gift of the real world is valuable in defending a future in which, it is hoped, other people can enjoy the wind howling through Douglas firs.

–Jim Cutler, 2003

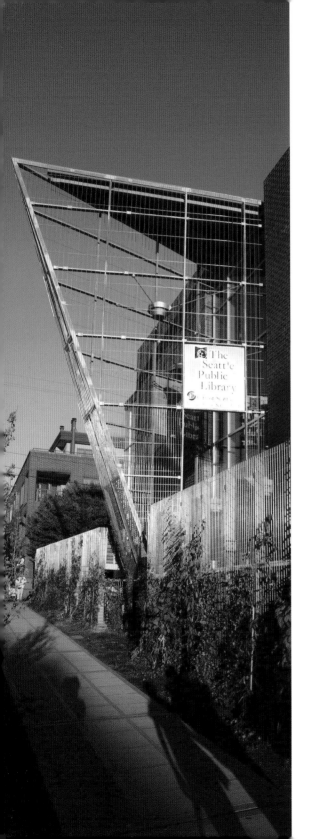

Introduction :
Out of the Woods

The work of the architectural design firm Cutler Anderson bears witness to the proverbial tree falling in the forest. Like the surveys they undertake at the beginning of each design, their work stakes a place in the world from which nature becomes visible. They believe that to know nature is to love it and to love it is to fight for its preservation. Nature is a complex word and, according to Raymond Williams, a history of its uses would be a large part of the history of human thought. For Jim Cutler and Bruce Anderson, the definition is simple: Nature is that part of the world that sustains humanity physically, emotionally, and spiritually. In this regard, architecture is problematic in that it devours unspoiled land and raw materials at an alarming rate. The logical conclusion is not to build unless you believe that beauty does not reside in objects but is in the eye of the beholder—thus leaving it open to manipulation. In essence, a building can help people see the forest in spite of the trees—and, for Cutler Anderson, this is the purpose of architecture: the realization of nature.

Ironically, Cutler Anderson is not considered "green" enough for many of the "green" architects who hold conferences in convention centers and officially designate the like-minded with special certification. At a time when this well-intentioned movement often produces earnest but uninspiring buildings, the firm makes an important point that emotions rally people faster than facts. A thousand projects with recycled carpet have less impact than one that reveals the beauty of the natural world.

Jim Cutler's sensitivity to the environment traces to his childhood in Kingston, Pennsylvania, a blue-collar coal-mining town surrounded by slag heaps. The son of a Russian immigrant who worked in a family-owned clothing store, Jim spent his childhood combing the woods for mushrooms; there he learned to be an acute observer of nature. At the University of Pennsylvania, Cutler won a coveted spot in Louis I. Kahn's postgraduate studio—the last Kahn taught before his death. On a personal level, the attention of one of the masters of twentieth-century architecture was an important validation of his talent, but, more importantly, Kahn taught Cutler how to think. He continues to approach design through the Socratic method Kahn used to explore the "existence of will"—the essence of a material and its highest and best use. Cutler continues where Kahn left off

when he speaks of honoring the trees felled to build a house. Otherwise, his wood-framed and glass designs appear on the surface to have little in common with Kahn's monumental brick and stone architecture. A closer look reveals Kahn's influence in Cutler Anderson's disciplined plans and the spiritual quality of space.

Where Jim Cutler breaks with his mentor is in Kahn's rejection of nature: "What man makes, nature can not make." In this regard, Cutler shares more with Le Corbusier and his deurbanization projects of the 1930s and 1940s, which sought a return to the conditions where people could contemplate and enjoy nature. This is key to understanding that Cutler Anderson's work is not confined to the woods.

A road trip brought Cutler to the Pacific Northwest in the early 1970s and to the balance between nature and culture—Bainbridge Island's forest of firs and rocky beaches is only half an hour by ferry to downtown Seattle—that ties him to this place. He founded James Cutler Architects on the island in 1977. The firm's work first came to national attention with a 1986 American Institute of Architects National Honor Award for the Parker Residence, built inside a recycled fishnet-drying shed. The project marks the beginning of what collaborator Peter Bohlin calls a progression from derivative to more personal designs.

Around this time, a former design student from a class Cutler taught at the University of Washington in Seattle, Bruce Anderson, joined the firm. He became a partner in 2001, and the firm's name changed to Cutler Anderson Architects. Well suited to their respective roles, the poet and the pragmatist, Cutler initiates conceptual ideas and works with Anderson to develop and refine them using a design shorthand developed through more than twenty years of working together. A Pacific Northwest native, Anderson's experience as planning commission chair and president of the Bainbridge Island Land Trust broadens the scope and reach of the firm, making him key in the firm's pursuit of public projects. Now a thirteen-person office, the firm is on the second floor of a converted boathouse on a Bainbridge Island marina, a short walk to the ferry to Seattle across Elliott Bay.

A breakthrough project in the theoretical development of the firm is the Virginia Merrill Bloedel Education Center on Bainbridge Island (1992). The poetry of this undertaking—the building memorializes the client's sixty-two years of marriage with a view of his wife's unmarked grave—resonated with the architects, and it was here they began their quest to honor felled trees with a design that displays every piece of wood. Here, Cutler Anderson began to fully articulate the relationship between architecture and nature with detailing that heightens awareness of materials and, by extension, the natural world.

Out of Bloedel came the commission of a lifetime, a house for one of the richest men in the world, Bill Gates (1998). Cutler Anderson, the only local firm invited to compete for the commission, joined forces with Peter Bohlin (as a graduate student, Cutler built models in Bohlin's Wilkes-Barre office) to win the 40,000-square-foot (3,716-square-meter) complex on Lake Washington near Microsoft's Redmond campus. The project gave the firm name recognition beyond the Pacific Northwest and the budget to experiment. The emphasis moves away from skin, as seen in the Parker Residence and earlier houses, to skeleton as the architects restate the meaning of wall, post, and beam, and their interrelation in space. The primacy of structure and the almost infinite variety of expression is shown in the multiple and subtle detailing of column and beam connections.

As with any project of this scope and stature, the Gates complex had its price, consuming the Cutler Anderson office for

seven years. Potential clients went on a wait list until the Gates project was finished, while others did not call because they thought the firm catered only to the extraordinarily rich. It was also a philosophical crisis for Cutler Anderson as they struggled to reconcile the vast consumption of natural resources in the Gates house—especially wood—with Cutler's reverence for trees. The project brought home the inherent critique of capitalism embodied by the green movement; it is no coincidence that the 1999 World Trade Organization riots occurred in Seattle, home of Microsoft, Boeing, and Starbucks. This may or may not explain why Gates chose Cutler Anderson for his architect (perhaps as a means to mend the rift between globalism and the environment on a personal level?) but, more likely, explains Cutler's current ambivalence about the project.

One client who waited was Barbara Wood. Her house (1998), on rural Vashon Island, Washington, is a seminal project for Cutler Anderson as they sought ways to achieve an articulated design on more modest budgets. Built-up sections of light wood framing and steel plates replace the heavy timber structure used at the Gates house. The literalness of exposing every piece of wood is also gone, replaced by glimpses of framing in

key places as the drywall stops short of the floor and the ceiling or is cut larger around windows to give every stud its due. The real discovery is in the greenhouse, where a concern about condensation led the architects to bolt standard window frames on the outside face of the wood framing. This frees the relationship between window and structure and marks the beginning of the layered transparency that is now the firm's hallmark.

These ideas were pushed to an extreme at Tanglefoot (2003), a house on a remote lake in Idaho for an inventor and his young family. The house represents an unusually close collaboration between Cutler Anderson and the client, who hunted down an aluminum tape (used in the aerospace industry) that enabled the refinement of the window system first used at the Wood residence. At Tanglefoot, aluminum bars and channels hold entire walls of glass away from the wood framing on aluminum spacers. The house is baroque in its fecundity, with multiple layers of wood framing inside mirroring the richness of the wilderness outside.

The pendulum swings the other way, toward spareness, with the Pine Forest Cabin (1999) in the semiarid forest of Methow Valley, Washington. On either side of a long wood platform, two balloon-framed walls continue unclad past

the building envelope to stretch space beyond the plan. The precision and control of the detailing underscore the light, ephemeral quality of the structure.

The firm's first major public project, a branch library designed in collaboration with Johnston Architects for Maple Valley, Washington (2001), shows how these ideas can transcend the domestic world and are, in turn, transformed by the transition from private to public. Without the budget or programmatic freedom of a house, time and effort focus on the essentials: simple geometries, structural clarity, and the connection to place. Like the houses, the library challenges conventions (the forest wasn't clear-cut to make room for a parking lot; instead, cars are slipped between trees) and creates personal places within a larger shared space.

These ideas and the methodology also ring true in the firm's first urban project, a branch library (also in collaboration with Johnston Architects) in Seattle's densest city neighborhood. With its monolithic brick walls, hollowed-out interior, and distinction between functional and honorific spaces, the Capitol Hill Library (2003) is overtly reminiscent of Kahn's library at Phillips Exeter Academy in New Hampshire (1972). But Cutler Anderson makes this library entirely their own, covering the walls and wrapping the interior with a vine-covered trellis that creates a vertical oasis in the city.

Grace Church (2003) on Bainbridge Island is the culmination of Cutler Anderson's investigations and intentions to date. It recalls the structural expressiveness and spiritual quality of Gothic cathedrals with exposed wood, articulated connections, and layers of glass. The spiritual connects to the secular through the gravitational forces made visible in the structure and in the big leaf maple framed by the sanctuary. Asked for an explanation of the design for the church's dedication, Cutler wrote, "God is manifest in the physics of the world." For him there is no distinction between form and content or between object and meaning, just as Susan Sontag wrote in *Against Interpretation* that modern art "should need no interpretation because whatever meaning it had was immanent in the sensory experience of the work." The firm holds this idea so dear that they, along with artist and collaborator Maggie Smith, brought a successful suit against the city of Salem, Massachusetts, to have an interpretive plaque removed from the Salem Witch Trials Tercentenary Memorial (1992). The memorial speaks eloquently for itself and the twenty innocent victims through the experience of the materials, trees, and space just as the cast bronze letters at the Armed Forces Memorial in Norfolk, Virginia (2000), give voice to the sacrifices made by servicemen and women who lost their lives in war. Memorials are an important part of the firm's work, providing the visual clues that can turn keys in locked hearts and release emotions in a rational world. For Cutler Anderson, architecture is the means for establishing the passionate connections—to the past, a place, and other people—that can change the world.

–Sheri Olson

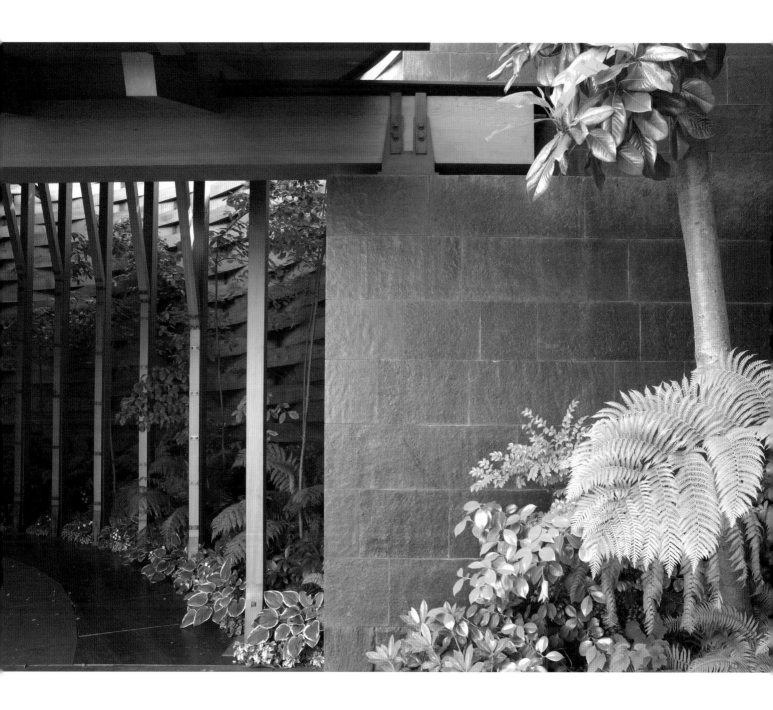

Entry Turnaround
Medina, Washington
(1994–1995)

This covered drop-off and turnaround accommodates the many guests visiting this private residential compound on the shore of Lake Washington. Designed in collaboration with Peter Bohlin of Bohlin Cywinski Jackson, the turnaround is along a winding drive from the street. The drive passes a guesthouse set into the steep hillside before sloping down to the entrance of the main house.

One of the challenges of the project was reconciling the linear geometry of the house with the circular geometry of the turnaround, which was dictated by the turning radius of a car. The design separates the two elements into a half-circle roof over the drop-off and a sloped plane of roof over the entry stair and then reconnects them with a covered walkway on the northern edge of the turnaround. Along the west side of the turnaround is a belvedere with views of the lake, Seattle's skyline, and the Olympic Mountains in the distance.

The heavy-timber half-moon roof is set within a 30-foot-high (9.1 m) retaining wall tucked into the hillside. Alternating sections of cedar timber stack to create the basketweave texture of the wall and create a finish face for the wood shoring and steel piling that hold back the earth. A space separates the half-moon of heavy-timber roof from the retaining wall, allowing light to trickle down and illuminate the turnaround. Massive stone piers on either side of the half-circle carry a heavy-timber beam across the space while a row of treelike columns forms a semicircle to carry the roof rafters.

BELOW ‖ Partial site and floor plan

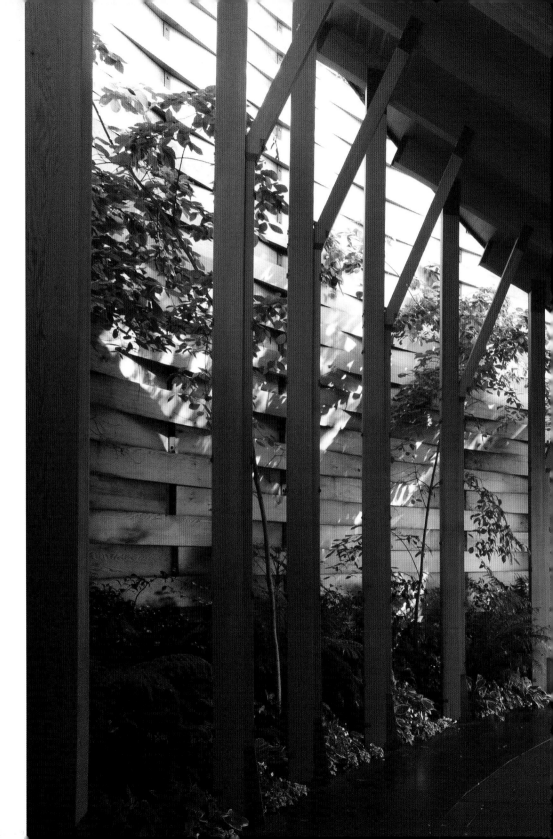

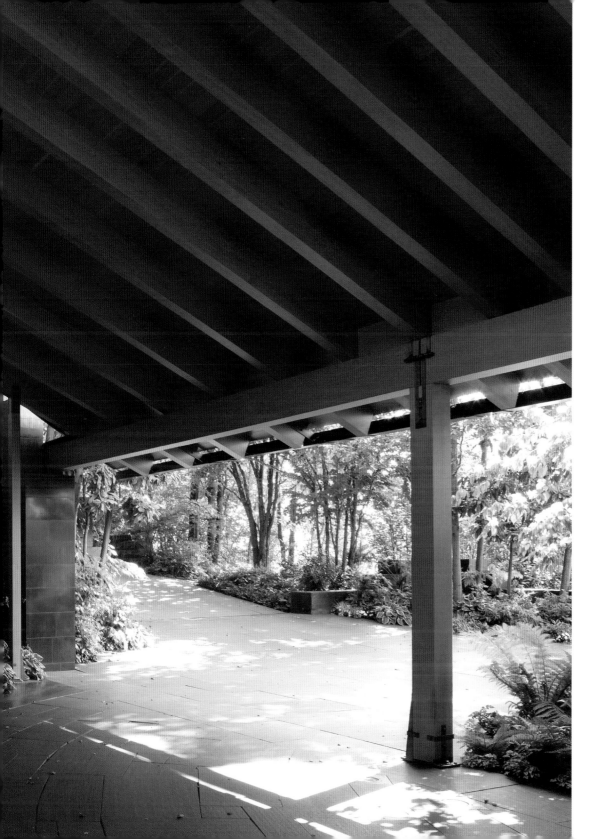

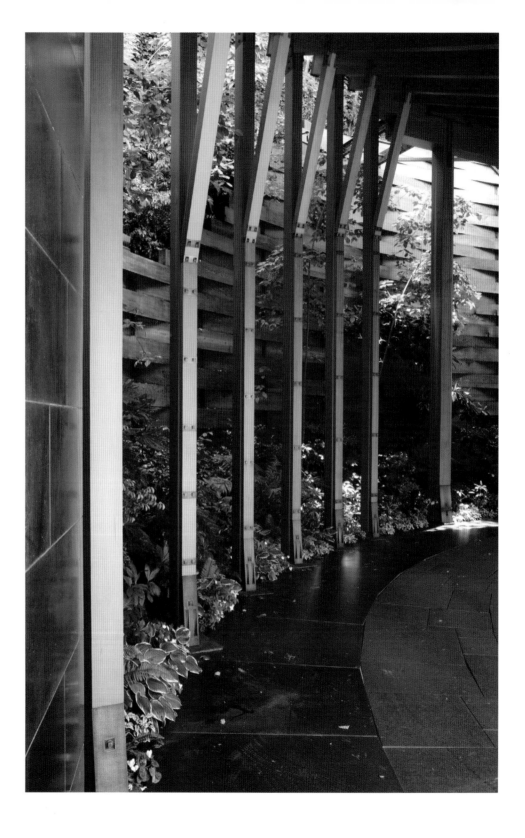

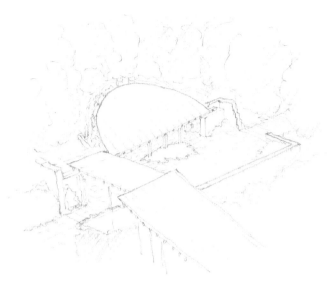

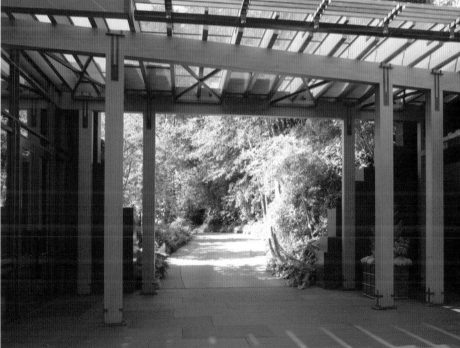

ABOVE ‖ Conceptual drawing shows a covered walkway connecting the semi-circular roof over the drop-off to the sloped roof at the front door of the house.

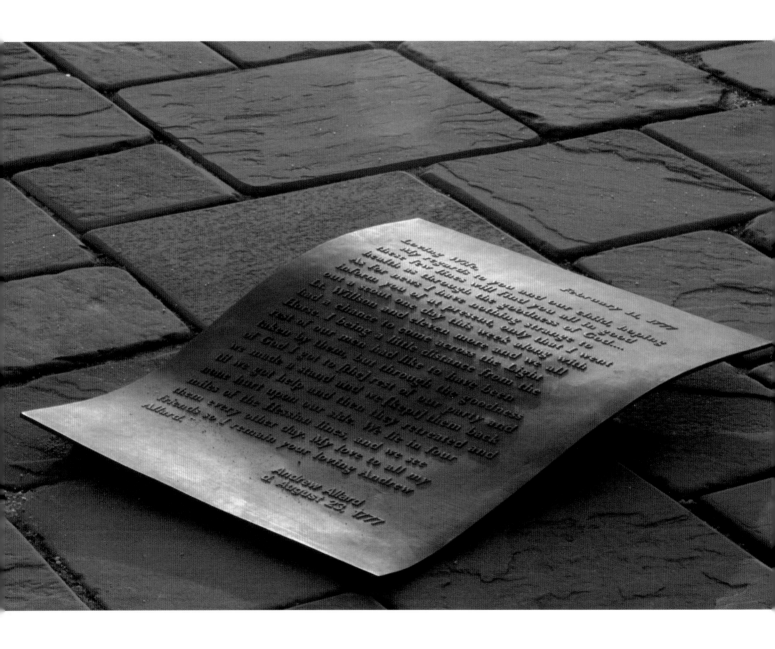

Armed Forces Memorial
Norfolk, Virginia
(1996–1998)

Letters by servicemen and women who died shortly after writing them commemorate U.S. citizens lost in war. Cutler Anderson won a national competition to design the memorial with artist Maggie Smith, who searched archives for letters from the Revolutionary War, the War of 1812, the Civil War, World Wars I and II, Korea, Vietnam, and the Persian Gulf, including one from a woman who served in the Civil War while posing as a man.

The memorial is on the most prominent point in Norfolk Harbor in Town Point Park, which runs along a pier overlooking an active industrial waterfront. To create an area for contemplation separate from the park, a bay was cut from the pier on each side of the memorial. Plank bridges cross the bays and provide a transition to the memorial plaza. Two sides of the 40-foot-square (3.7-square-meter) plaza open to the harbor; the landward sides are bound by low brick walls that recall fortifications built by the British on the point in the 1600s. Inscribed on the wall on either side of one bridged entry are the words of Archibald MacLeish: "We give you our deaths, give them their meaning."

The twenty bronze letters look scattered across the granite plaza as if blown in from the distant battlegrounds where U.S. citizens were killed in action. Each is three times actual size and was shaped by hand in wax before being cast in bronze. Addressed to mothers, fathers, wives, and friends, the inscriptions reveal the range of beliefs, thoughts, and emotions that form the history of the nation. Visitors bow their heads or kneel as they read in quiet reflection. Neither heroic nor monumental, the personal nature of the letters connects the living with the dead and makes their sacrifice heartfelt.

BELOW ‖ **Plan of Town Point Park and memorial**

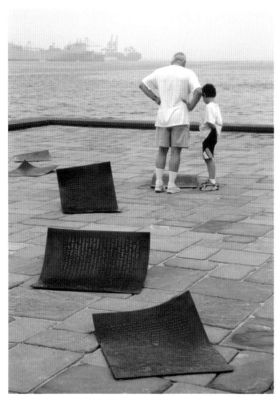

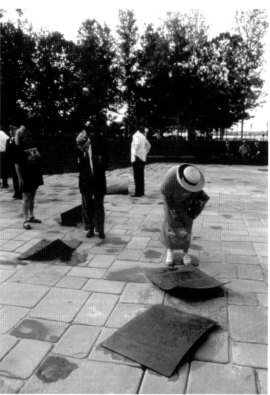

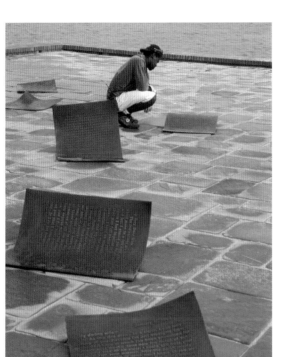

Dear Mother,

Even the trenches can be beautiful when they are trimmed with flowers, and the barbed wire forms a trellis for rambling vines, and shelter for innumerable thrushes and other songsters—one explanation, no doubt, of why the cats have a penchant for No-Man's-Land. The birds warble all the time, even when there is considerable activity, and it seems to me that their voices never sounded so sweet before. A number of them inhabit the six small trees, two birches and four wild cherry, which rise on the central island (entirely surrounded by trenches) of my strong point, or *groupe de combat* as the French call it. At the base of one of the birches is a flourishing wild rosebush, literally covered with blossoms, some of which I sneaked up and picked—keeping not only head but also the rest of me carefully down during the process Here are some of them for you, and also some daisies and yellow asters from the edge of one of my trenches.

Quincy Sharpe Mills
d. July 26, 1918

LEFT ‖ The memorial is on the most prominent point in Norfolk Harbor in Town Point Park, which runs along a pier overlooking an active industrial waterfront.

Wood Residence
Vashon Island, Washington
(1995–1998)

A shimmer of metal roof is the first glimpse visitors get of this house along a circuitous path through the woods. The house, designed for two retired doctors, is on rural Vashon Island only a short ferry ride from Seattle. The 20-acre property runs from forest to meadow, but the two were indistinguishable due to dense overgrowth of alder. The 2,330-square-foot (216-square-meter) house is a series of five pavilions that nestles along the edge of the forest to draw attention to the subtle change in the landscape.

The entry is a glazed knuckle between a public "day box" and a private "night box." The main living area is a large, open room in the "day box" that includes a dining area and kitchen. As with all of the pavilions, the roof over the living room starts low on the forest side and rises to a wall of windows facing the meadow. A covered exterior walkway connects the pieces along the forest edge. The other pavilions contain a laundry/mud room, a greenhouse, and a garage. The wife is an avid equestrian and her husband is allergic to horses, and this arrangement allows her to shower in the laundry before she passes from a nearby stable to the house.

Throughout the house, the detailing maximizes the expressive potential of light-wood framing. Beams and columns are sandwiches of standard 2-by-8 lumber that alternate with steel knife plates. Finish materials—whether drywall or tongue-and-groove pine—stop several inches shy of the floor and ceiling to reveal the stud wall behind. They are also held back around the window openings, reducing the finishes to skins that stretch sparely over the wood skeleton beneath. A detail, now standard in the firm's vocabulary, first appears in the greenhouse, where the window frames sit on the outside face of the wood framing so the glass resembles a taut skin over a structural skeleton.

BELOW ‖ **Site and floor plan**

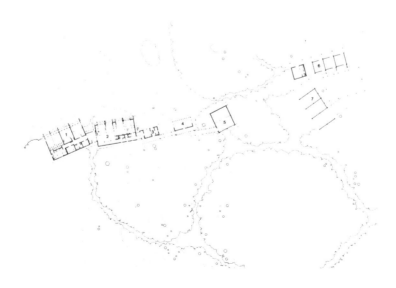

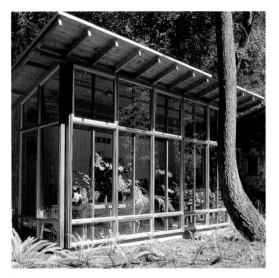

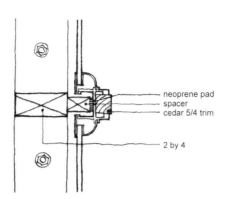

neoprene pad
spacer
cedar 5/4 trim

2 by 4

LEFT (DRAWING) ‖ The window frame is set on top of the wood studs in the greenhouse—an unusual detail now that is now a hallmark of the firm's work.

BELOW ‖ The house is a series of boxes placed to respond to the nuances of the topography and to preserve trees. Circulation is on the north along the woods, with the living spaces open to a meadow on the south.

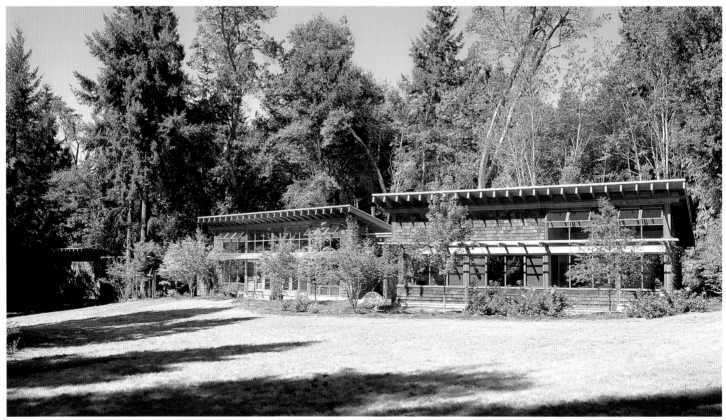

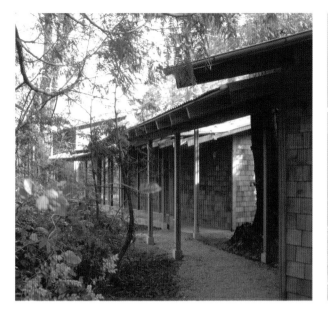
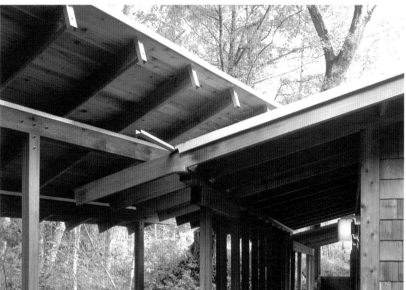
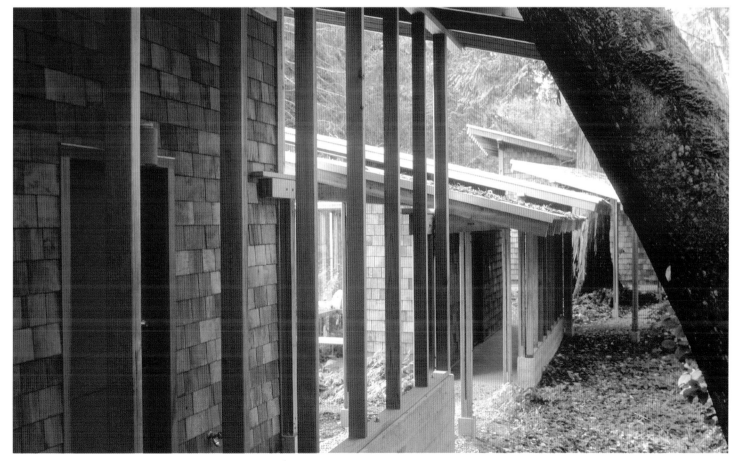

RIGHT ‖ The main living space is a large, open room with areas for entertaining, dining, and cooking. The light-wood framing both defines the space and penetrates the window wall, extending it outside.

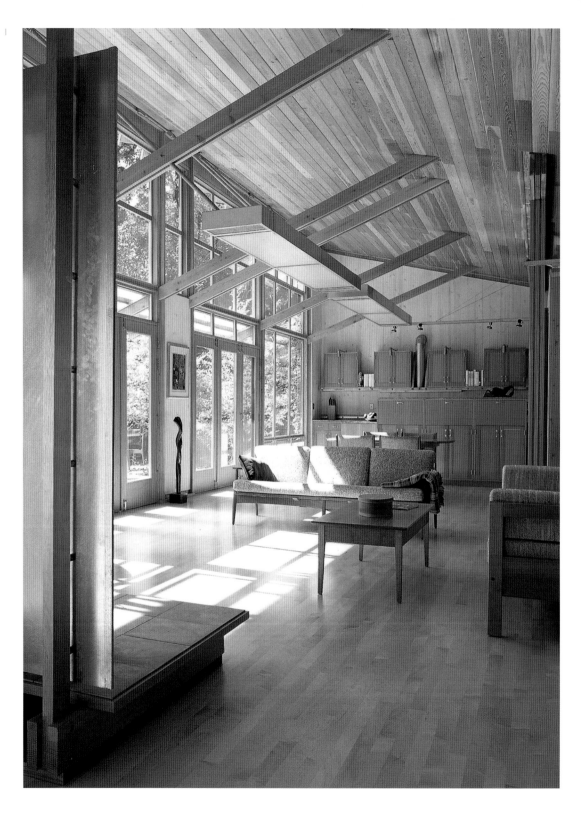

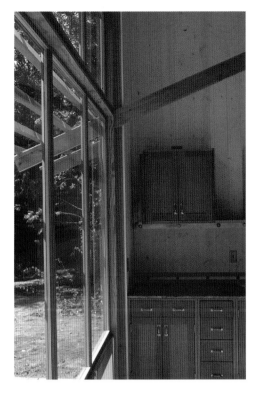

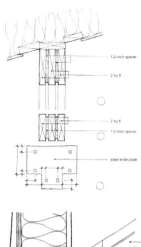

1/2-inch spacer

2 by 8

2 by 8

1/2-inch spacer

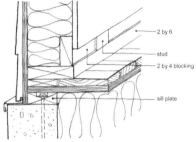

steel knife plate

2 by 6

stud

2 by 4 blocking

sill plate

LEFT (DRAWING) ‖ The wall finish stops several inches shy of the floor to show the wood studs; The beams are 2-by-8s that alternate with wood spacers. Steel knife plates join the beams to the columns.

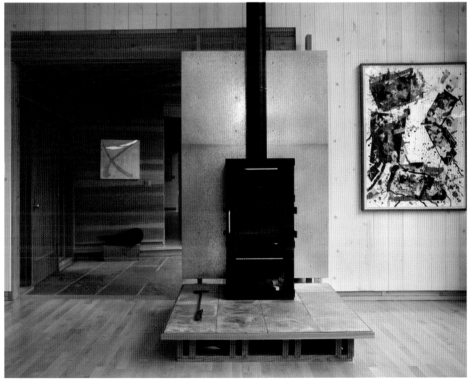

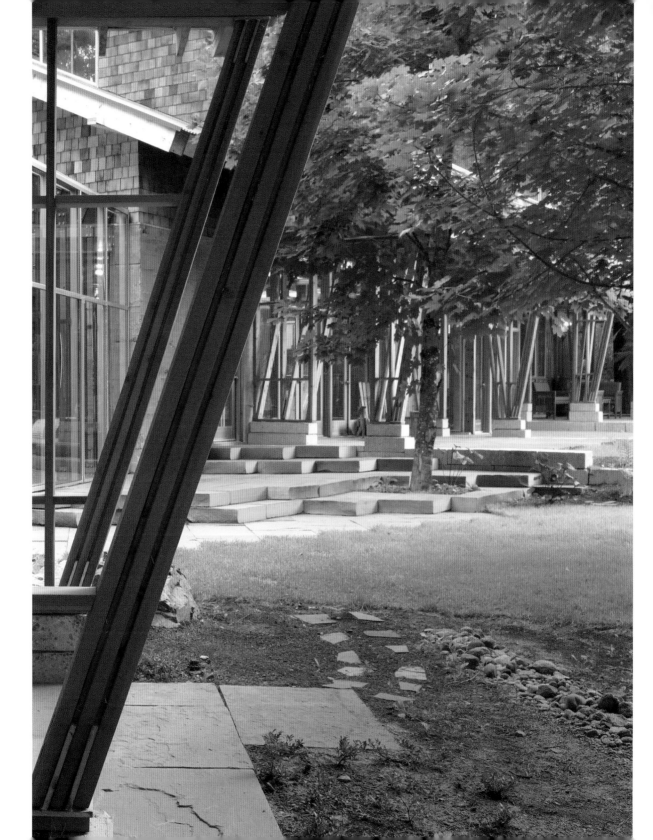

Tanglefoot
Priest Lake, Idaho
(1997–2001)

Large tracts of undeveloped land harboring grizzlies, mountain caribou, and moose surround this 19-mile-long (30.5 km) finger of water in northern Idaho. The owners rely on their small fleet of amphibious planes to get to this remote, 6,000-square-foot (557-square-meter) house on a lake. Built for the inventor who developed the birthing beds now used in most maternity wards, his wife, and their four young children, the richness of detail and structural articulation is a result of a fruitful relationship between client and architect.

To slip the house between the trees along the shoreline, it was broken into separate summer and winter blocks connected by a double-height 750-square-foot (69.7-square-meter) greenhouse that becomes a living space during mosquito season. During cold months, the summer block—with a master suite above and a conference room below—is closed, reducing the area needing heat. The balance of the living space, including the living room, kitchen, and children's bedrooms, is in the winter block.

The shingle roofs slope up, away from the view of the lake toward the woods, to capture southern light. An open catwalk passes through the light-filled double-height space along the south edge of the winter block and the greenhouse connecting the children's second-floor bedrooms to the master suite. The bedrooms are in large dormers that pop up above the roof to capture lake views on the north. They also project beyond the first floor and are held aloft by large wood brackets that define covered porches.

Wall finishes are almost entirely eliminated inside, and the exposed wood framing visible through large panes of glass blends with the tree trunks outside. Without wall finishes, though, elements typically hidden must be rethought. In this case, industrial explosion-proof switches replace standard electrical switches and galvanized steel conduits are substituted for standard electrical outlets. The kitchen is another example of rethinking industry standards. It is a room-sized stainless-steel channel holding commercial grade appliances and cabinets inserted into the wood frame of the house.

BELOW ‖ **First floor and site plan.**

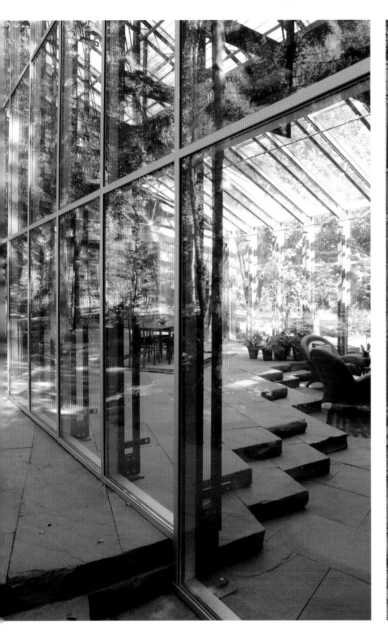

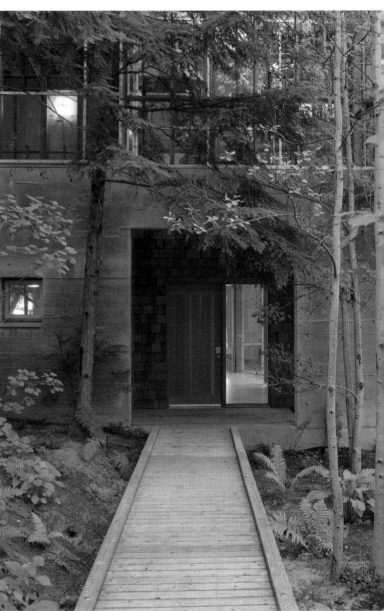

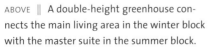 ABOVE ‖ A double-height greenhouse connects the main living area in the winter block with the master suite in the summer block.

OPPOSITE ‖ To fit the house between the trees and along the shore of the lake, the house is a series of connected pavilions.

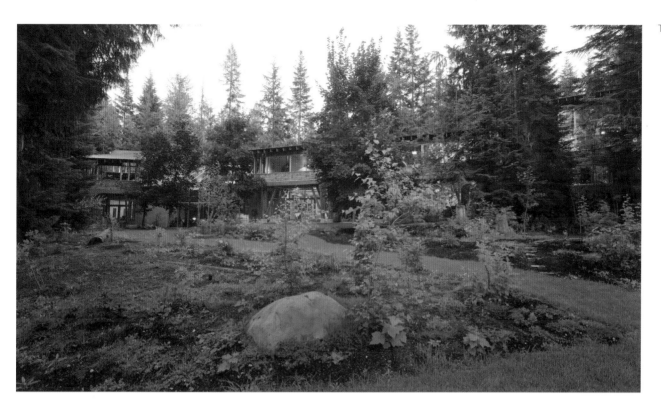

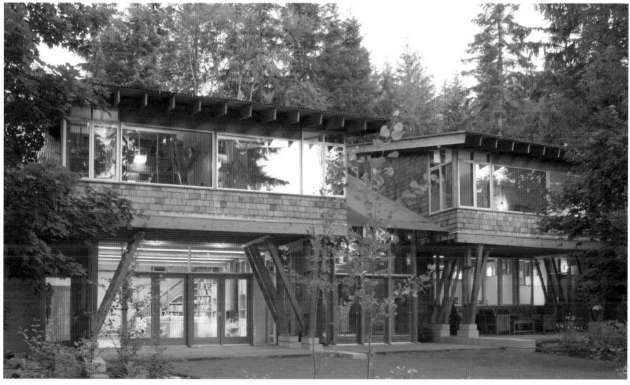

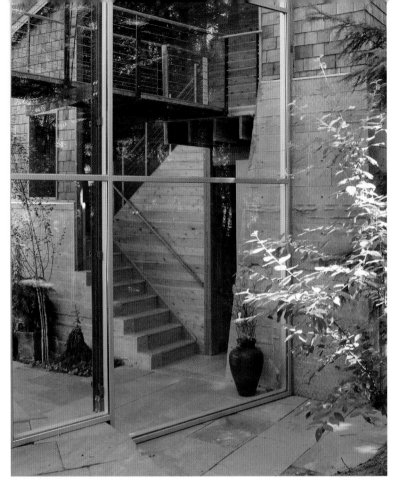

RIGHT || Blocks of stone pavers continue outside from the greenhouse for a seamless transition between spaces.

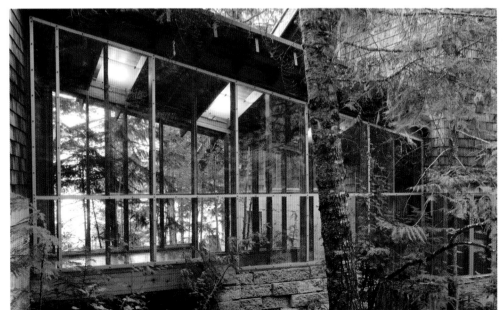

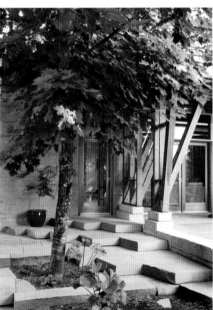

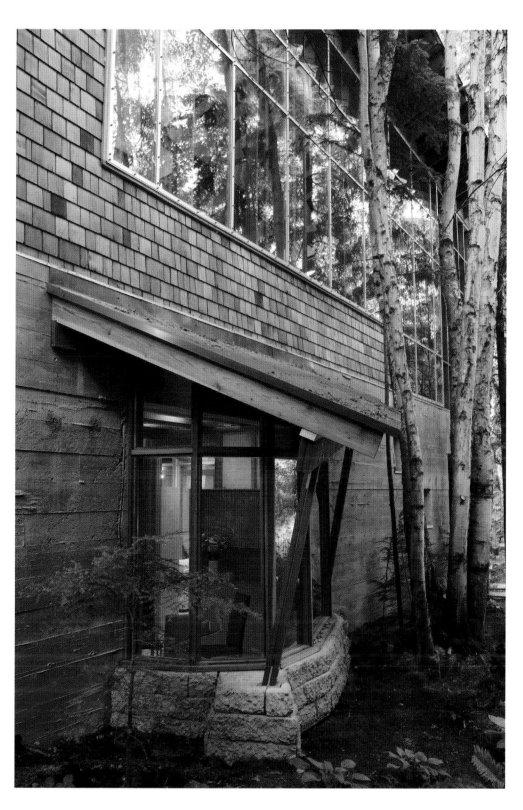

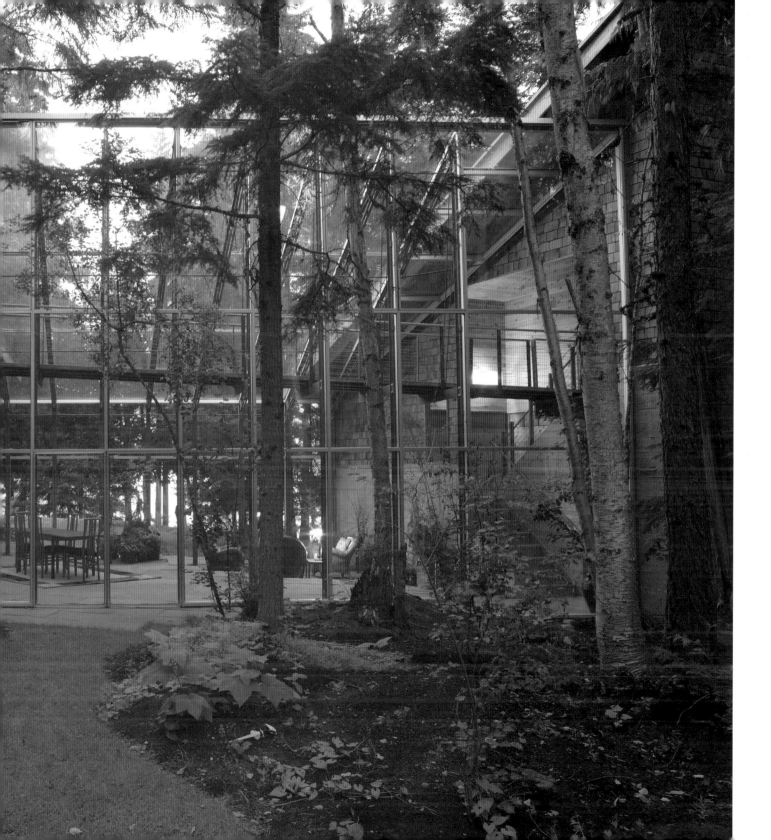

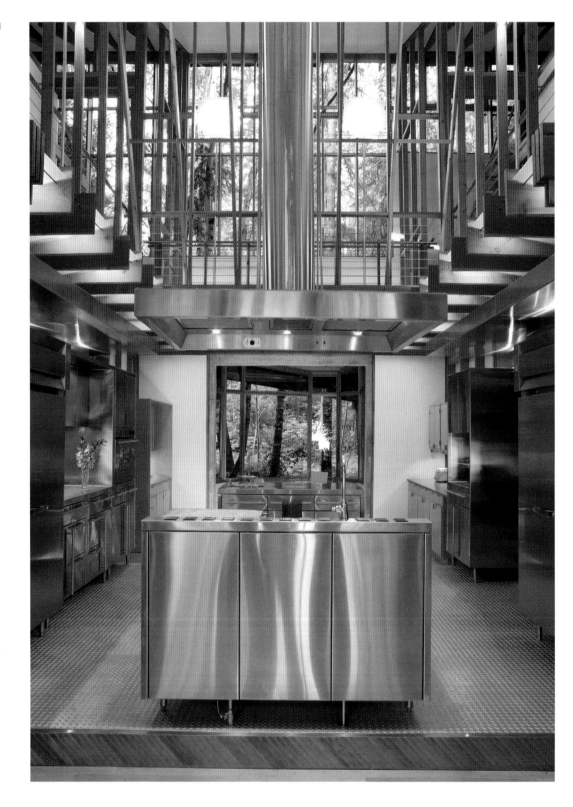

RIGHT ‖ The kitchen is a stainless-steel object set within the exposed-wood frame of the house.

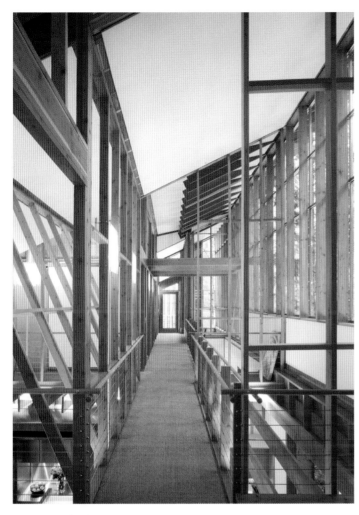

LEFT ‖ A catwalk over the kitchen connects the master suite to the children's bedrooms.

BELOW ‖ Aluminum spacers float a frame of aluminum channels off the face of the wood studs. The windows sit within the frame, but the tight tolerances and unusual configurations made flashing difficult until the client hunted down rolls of aluminum tape used in the aerospace industry.

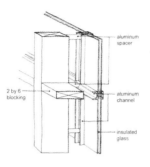

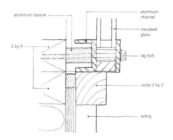

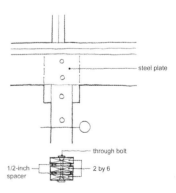

ABOVE ‖ To accommodate Idaho's snow loads, the steel plates sandwiched between wood framing dip below the bottom of the roof beams. Galvanized freeze plugs such as those found on engine blocks are covers for the bolt ends.

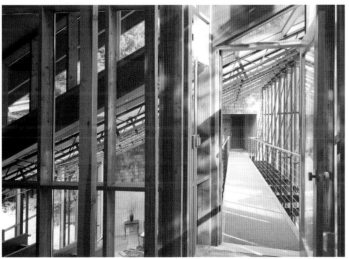

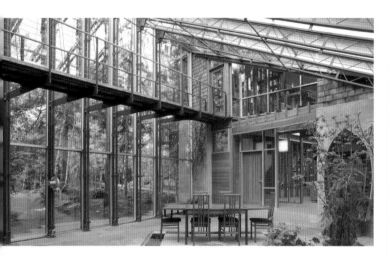

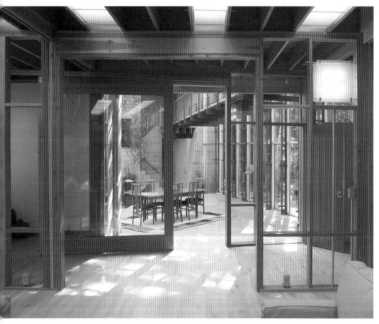

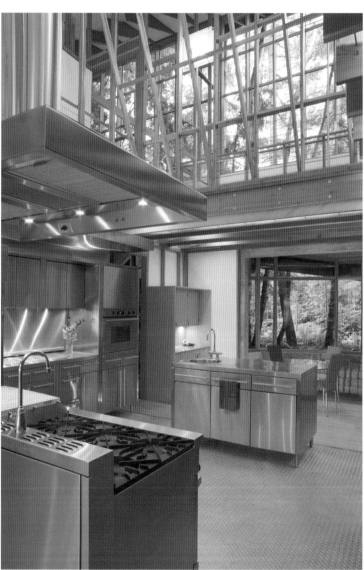

ABOVE ‖ The wood framing visible through the glass echoes the tree trunks and blurs the boundary between inside and outside.

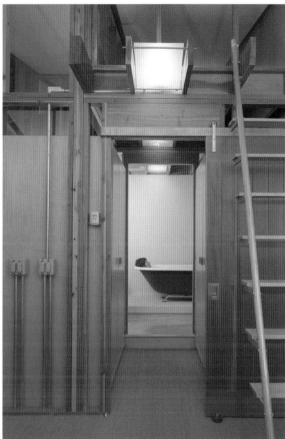

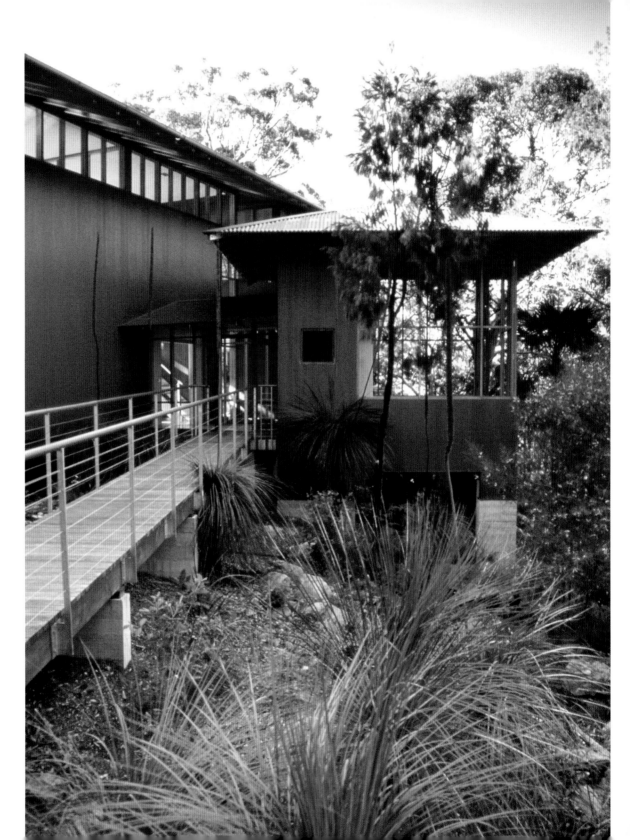

Hewitt Residence
Pittwater, Australia
(1996–2000)

This house, in a pocket of dense forest in a boulder-strewn valley north of Sydney, was an opportunity to work in a climate completely unlike that of the Pacific Northwest's evergreen forests. It is one of nineteen houses that form part of an environmentally sensitive development in which 12 of the 31 acres are held as a common nature preserve.

The geology of the area is ancient and features enormous "floater" rocks exposed by thousands of years of erosion of the surrounding sandstone. The 4,000-square-foot (372-square-meter) house is set in a natural clearing among large boulders on top of a hill. A bridge on axis with a large specimen gum tree cuts diagonally from a rock outcropping to a glazed entry between the main house and the library. The library is a self-contained cube set at an angle to define the entry. With 13-foot (4-m)-high windows wrapping three sides, the space feels like a tree house set in the jungle.

The main house has two metal-wrapped cubes framing a double-height space. The north cube contains the garage on the first floor and the children's rooms above, while the south cube has the living room and the master suite above. The kitchen, with a loftlike playroom above, straddles the central open space. Floor-to-ceiling windows and glass doors open to a large deck overlooking the jungle and distant views of the Pacific Ocean, almost 2 miles (3.2 km) away.

All exterior surfaces are metal due to the ever-present danger of fire, and the corrugated metal siding wraps the end cubes into the interior to increase the sense of continuity between inside and outside. The spaces are united by an overriding corrugated metal hip roof. In the event of a bush fire, sprinklers under the eaves will wash the exterior walls with water drawn from tanks under the house.

BELOW ‖ **Site and first-floor plan.**

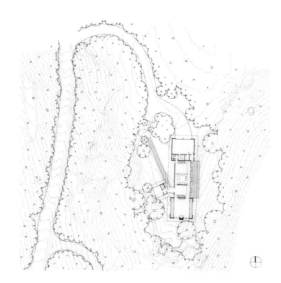

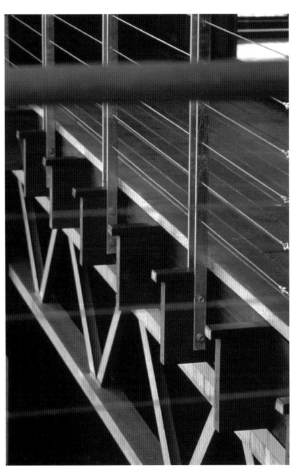

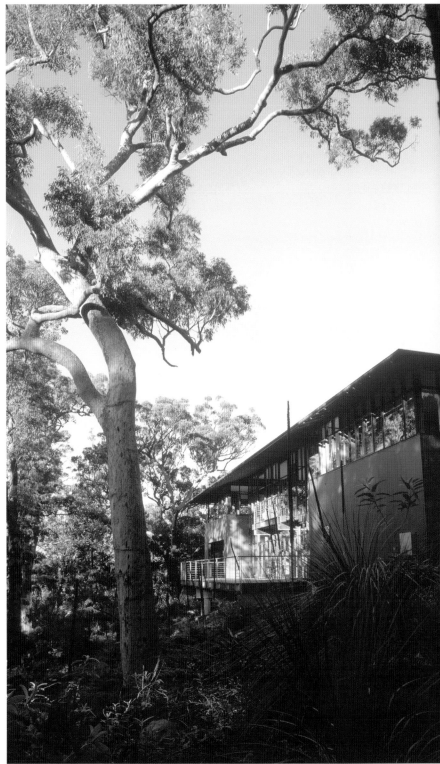

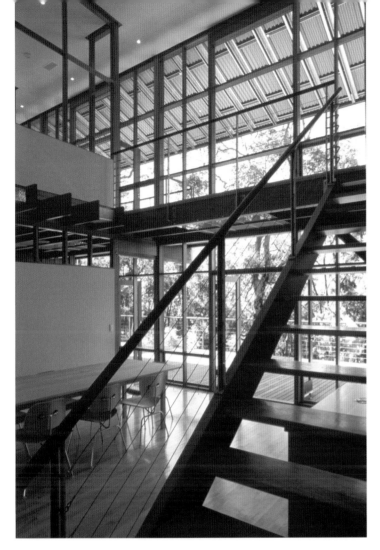

LEFT ‖ The kitchen, with a playroom above, straddles the main living space and offers distant views of the Pacific Ocean. The metal materials on the exterior give way to exposed wood inside.

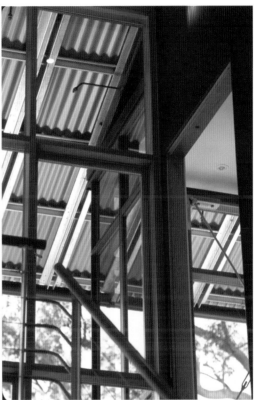

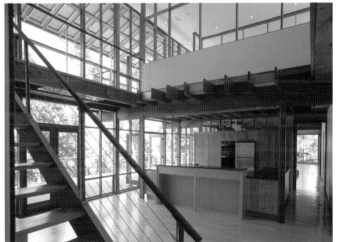

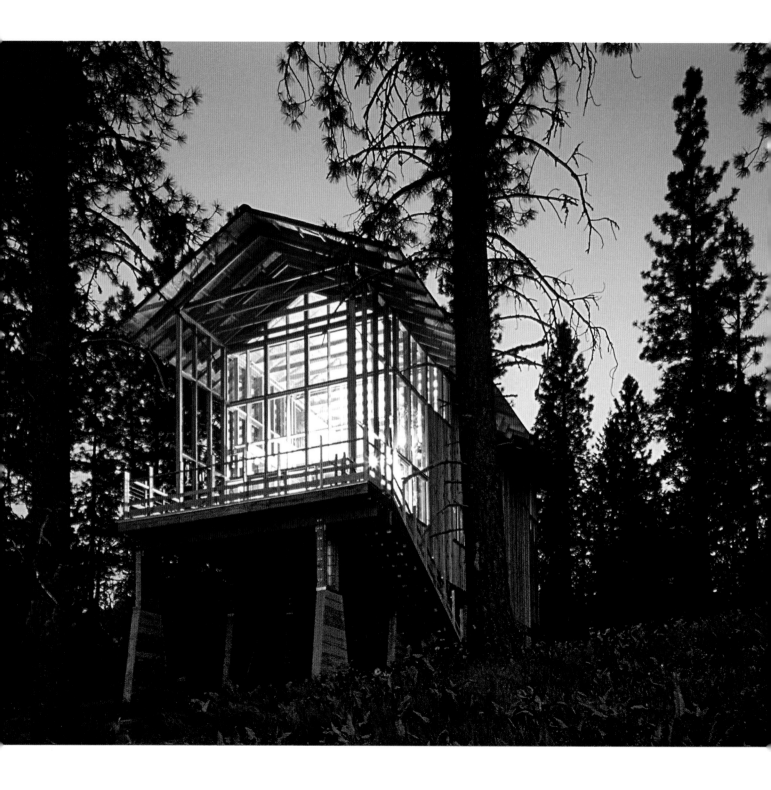

Pine Forest Cabin
Methow Valley, Washington
(1997–1999)

Tall and laconic like the surrounding pines, this 1,350-square-foot (125-square-meter) cabin has a large gable roof that gives it an iconic form. The cabin is a year-round retreat for a couple and all of their multi-season outdoor gear. The 5 acres of semi-arid forest is part of a vacation home development in the bucolic Methow Valley, east of the snow-tipped Cascade Mountains in north-central Washington.

The roof shelters a 16- by 65-foot (4.9- by 19.8-meter) wood platform that hovers above the steeply sloped land on seven pairs of board-formed concrete piers. Wood-framed walls, 18 feet (5.7 m) high, run the length of the platform and are exposed at both ends of the cabin at the porches. In between, the cladding transitions from more enclosed vertical wood siding to a two-story wall of glass. The detailing of both the wood siding and glass emphasizes the sense that the cabin's skin is lightly attached to the framing.

Two wood steps cantilever out from the main structure to welcome visitors to the front porch. A large overhang protects the south-facing porch from summer sun and winter snow. A glass door and a strip of high second-floor windows are the only openings that greet visitors on this wood-clad face. Inside, the long sidewalls and minimal windows of the open living area create a sense of enclosure before opening to the glassed-in two-story space at the north end of the cabin. The exposed wood framing continues outside, dissolving the boundary between indoors and out, structure, and trees.

The compact plan organizes built-in seating, storage, and bathrooms along the sidewalls, which frees the interior space. Upstairs is a bedroom and a loft that opens to the north-facing living space and shares its expansive views of the valley below.

BELOW ‖ **Site and first-floor plan.**

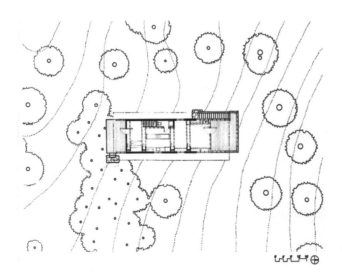

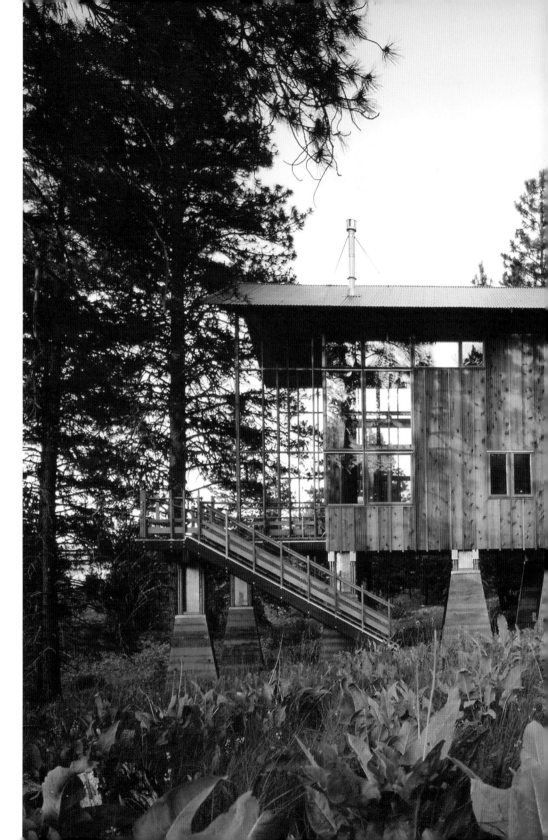

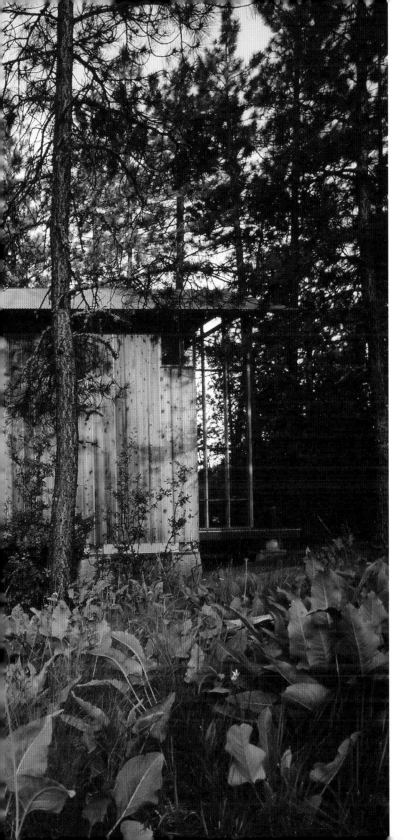

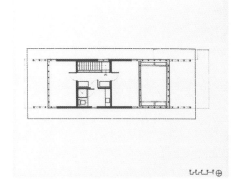

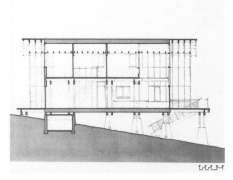

ABOVE ‖ Second-floor plan; Building section

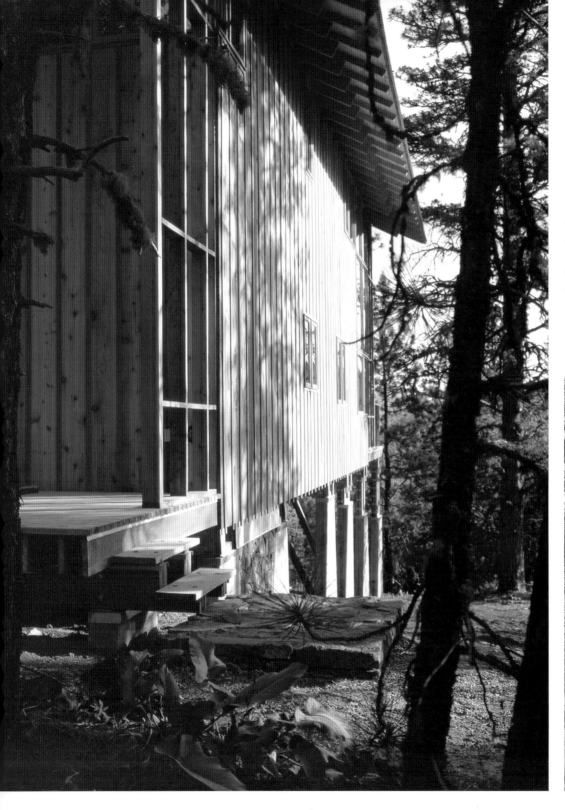

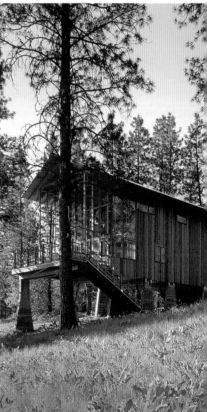

LEFT ‖ The balloon-framed walls run the length of the platform and are alternately exposed, clad in wood siding, or visible behind panes of glass. The detailing emphasizes the sense that the cabin's skin is lightly attached to the structure.

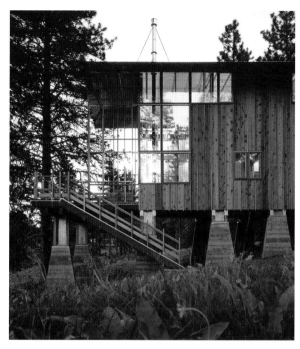

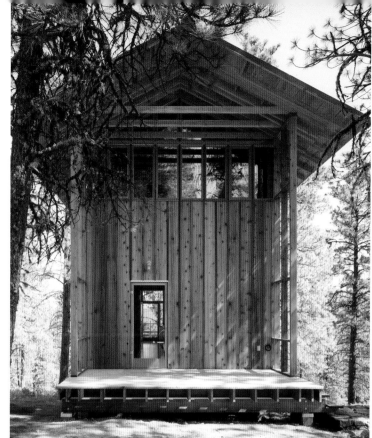

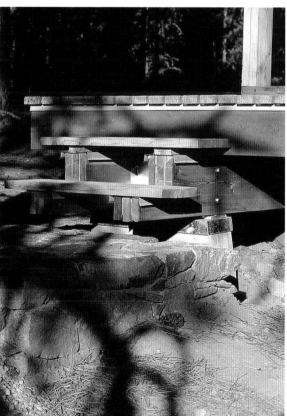

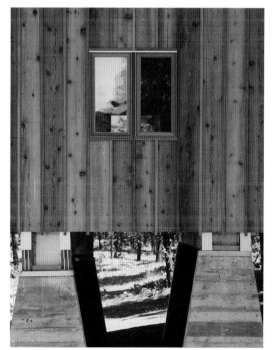

BELOW ‖ Steel plates connect the triple 2-by-12 columns to battered concrete piers.

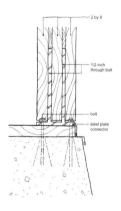

2 by 8

1/2-inch through bolt

bolt

steel plate connector

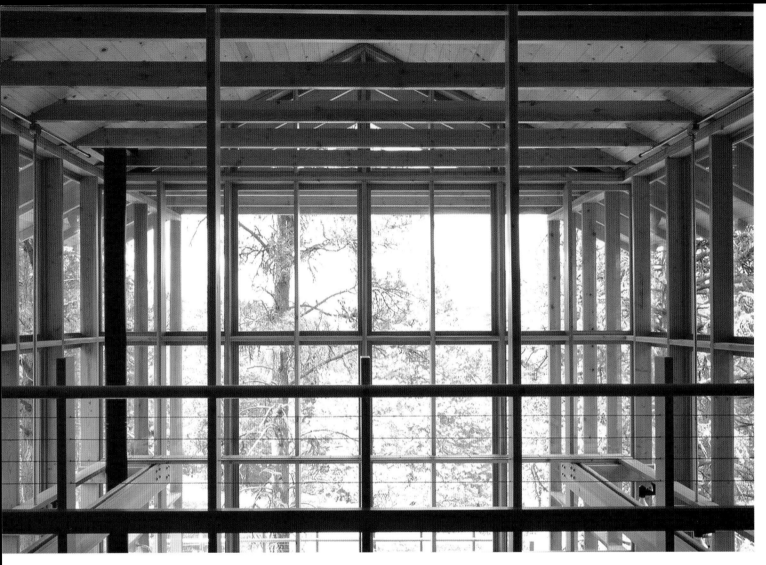

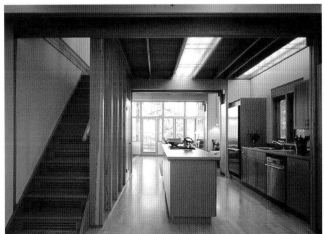

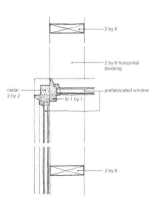

2 by 6

2 by 6 horizontal
blocking

cedar
2 by 2

prefabricated window

fir 1 by 1

2 by 6

ABOVE ‖ Layers of structure and large areas of glass foster a seamless connection between the cabin and the forest.

LEFT ‖ The window wall turns the corner between the studs, underscoring the continuity of the wood framing.

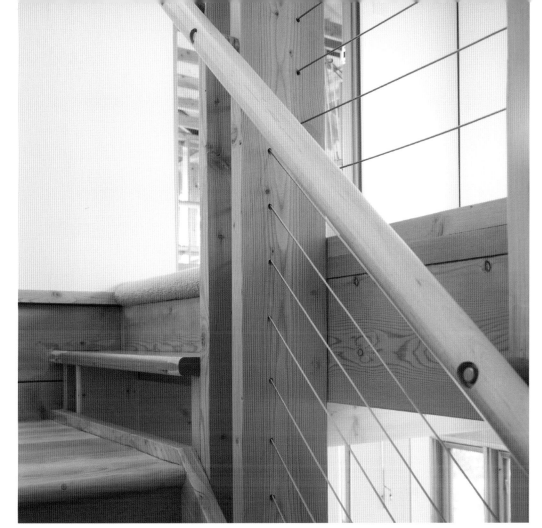

LEFT ‖ The exposed structure of the staircase supports the stringers and forms the guardrail.

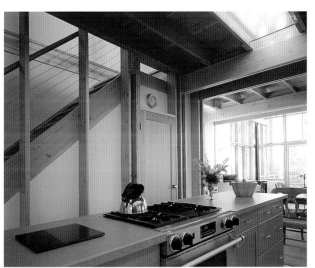

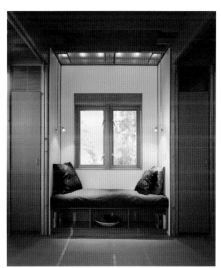

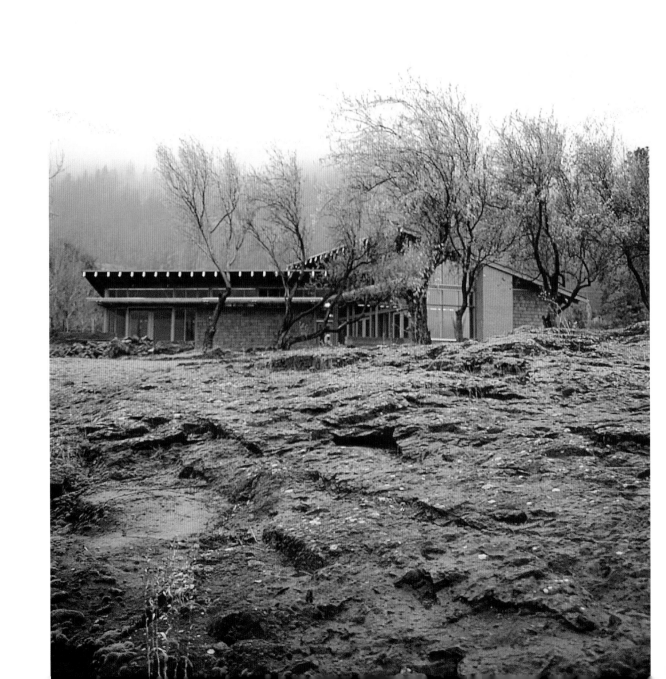

Columbia River Residence
Hood River, Oregon
(1999–2001)

This retreat straddles the transition line between desert and forest, sage and pine, along the south shore of the Columbia River. It is one of twelve houses built in a narrow strip of land between highway and railroad tracks along the base of the Cascade Mountain Range and the spectacular gorge. For years the clients roughed it in a 600-square-foot (56-square-meter), sod-roofed bunkhouse (also designed by Cutler Anderson) that sleeps sixteen while they enjoyed world-class windsurfing on the river.

The clients wanted to feel as if they were alone on the river, so the 1,400-square-foot (130-square-meter) house is split into two boxes angled to block views of the neighbors and the lights of the town of White Salmon across the water. The two splayed boxes intersect but maintain separate identities due to the distinct planes of their metal shed roofs. The shed over the master bedroom suite is lower, allowing the main living area roof to float above it. Clerestories between the two roofs bring light into the interior.

The entry is at the intersection of the two structures and is one of the few openings in the largely opaque south façade. A berm of earth covers the first few feet of a concrete retaining wall, and the low overhang of the eave nestles the house into the landscape to increase the sense of privacy. Inside, the roofs slope up to 15-foot-high (4.6 meter) glass walls facing the river. The exposed beams and roof rafters of the bedroom box continue under the roof of the main living and dining space, supported on a pivotal column that acts as a hinge. From here, the house splays open to an outdoor terrace with low retaining walls that stretch north toward the river.

BELOW ‖ Site and floor plan

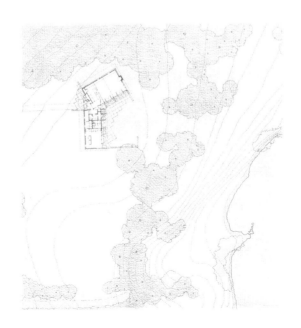

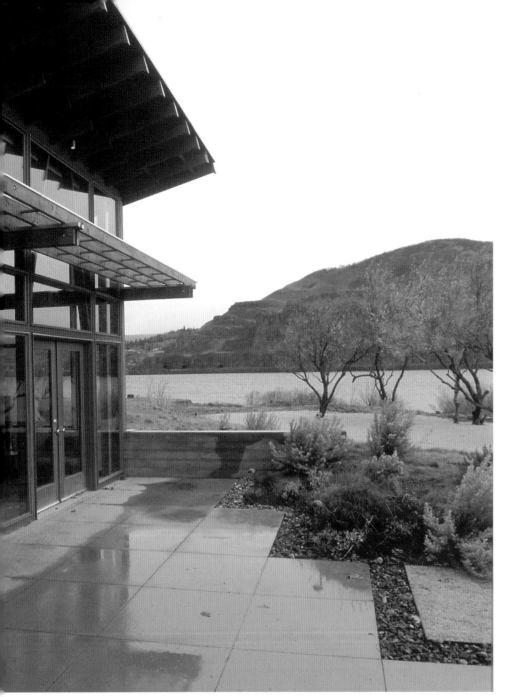

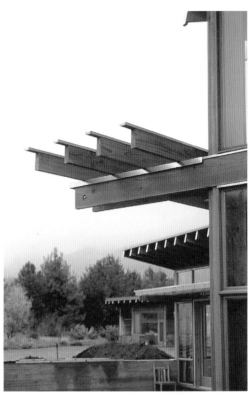

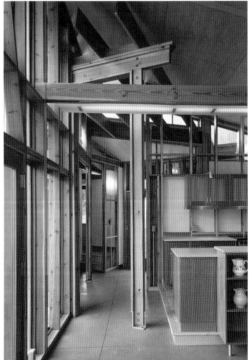

RIGHT ‖ A column marks the intersection of the two main volumes and supports the rafters of the low shed roof as it penetrates the living area. It's a complex detail that adds structural expression to a spare design.

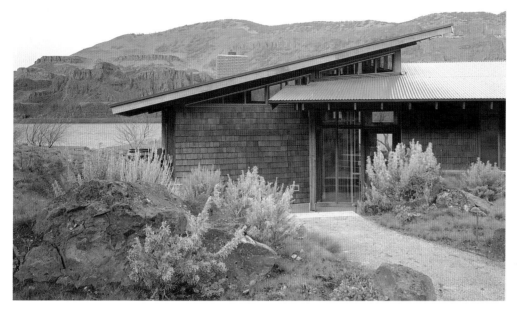

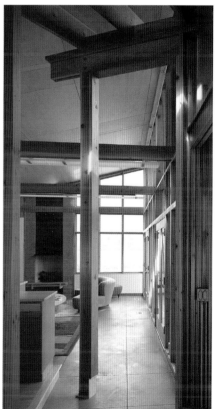

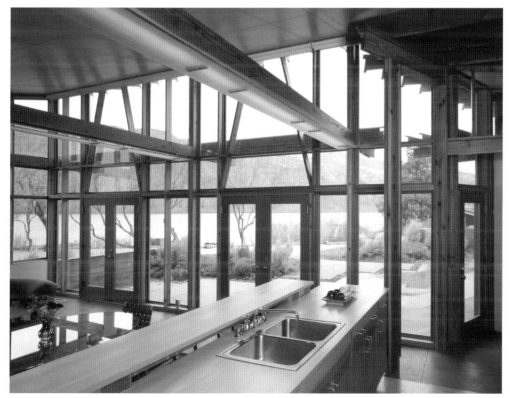

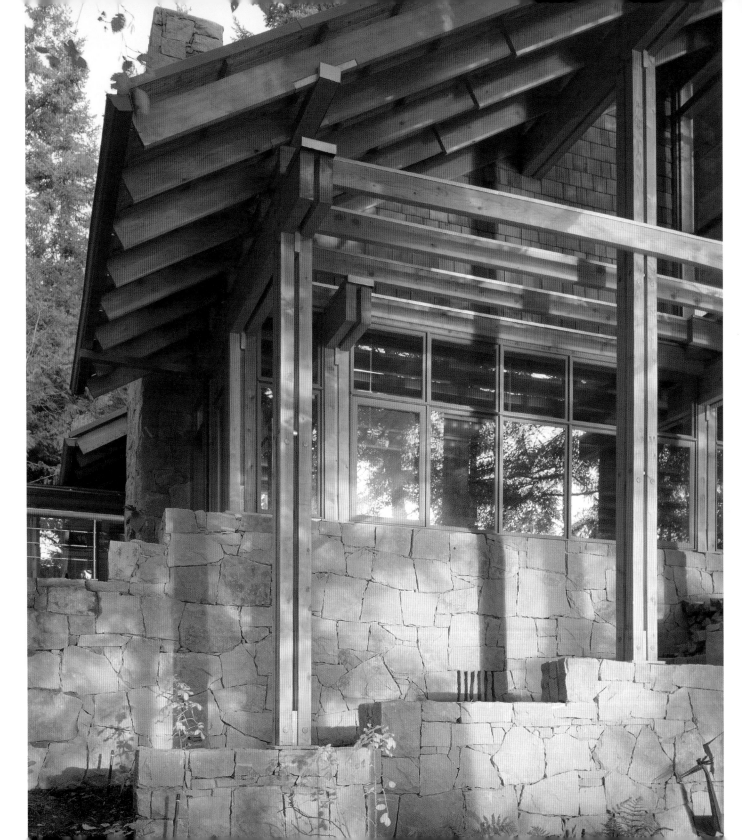

Schmidt Residence
Sequim, Washington
(1998–2000)

A beloved family cabin once stood in this clearing above Sequim Bay on the Olympic Peninsula. The land belonged to the wife's parents, and when it came back on the market, the Bay Area–based couple seized the opportunity to build their own waterfront vacation home.

The 4,500-square-foot (418-square-meter) house is split into two structures. A glazed walkway connects the main living area (with a master bedroom above) to an outbuilding containing guest rooms, a model train room, and the garage. The two wings sit perpendicularly and enclose a generous outdoor terrace, complete with fireplace, overlooking the water. The house's simple gable forms and exposed structure are set on a stone plinth and resemble a tent pitched on a platform in the woods. In some places, the stone is higher, forming fireplaces, and in others it extends out as low walls that anchor the house to the landscape or step down to the shoreline.

A long plank boardwalk through the woods to the house parallels the slope toward the water but reveals only glimpses of the bay. The front door is set perpendicular to the gable end so visitors enter under a low eave before turning into the main living area and toward an uninterrupted water view. The first floor is completely open with low cabinets, overhead beams, and a fireplace defining the kitchen, dining, and living areas. Instead of heavy-timber posts and beams, the structure features pairs of lightweight wood framing, adding to the buoyant quality of the space. The beams and columns continue beyond the glass skin of the house, dissolving the boundary between inside and outside.

BELOW ‖ **Site and first-floor plan**

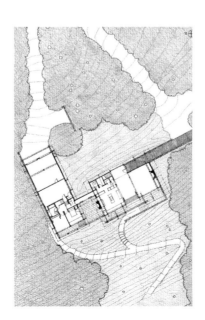

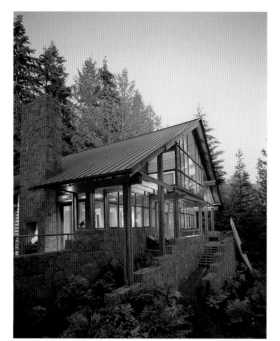
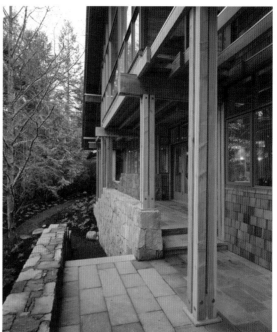
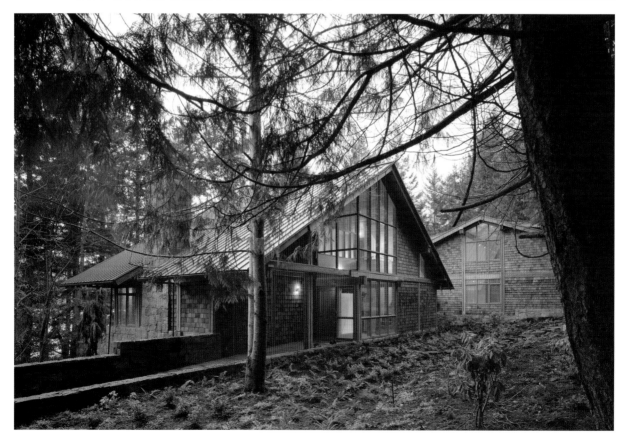

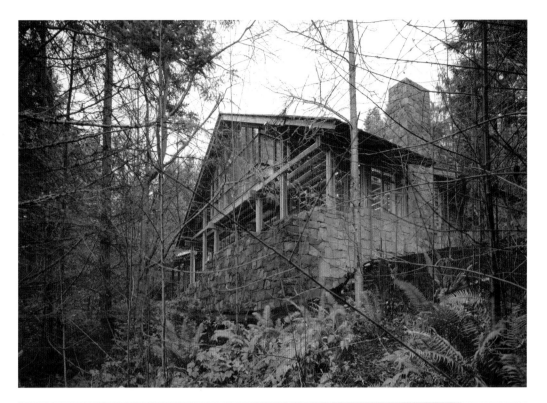

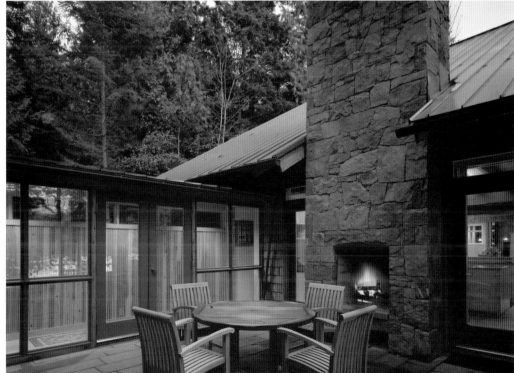

LEFT ‖ The two wings of the house enclose an outdoor terrace, complete with fireplace, that overlooks the water.

BELOW ‖ The main house, with an open liv-ing-dining room on the first level and master suite above, can be closed off from a second building, which contains guest rooms, a model train room, and a garage.

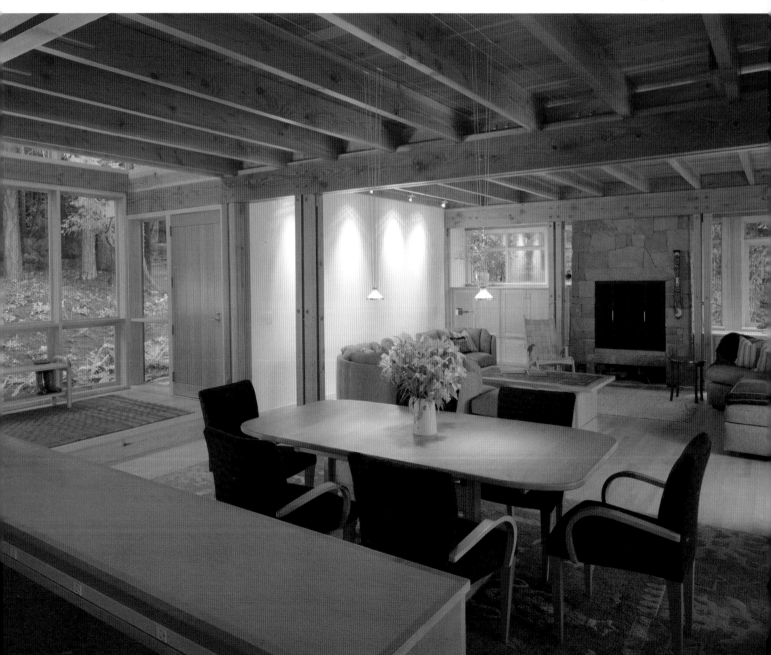

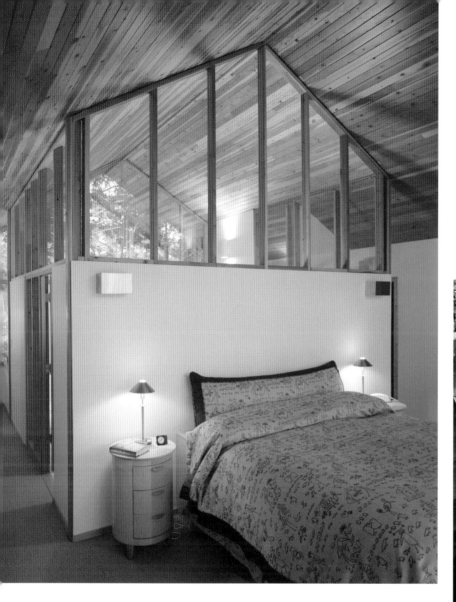

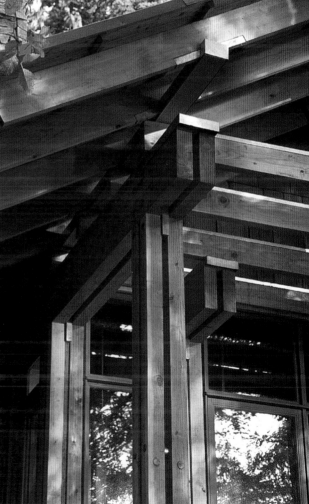

RIGHT ‖ The wood columns and beams continue beyond the glass panes, extending the interior space outside. The detailing of the posts and beams recalls the structural expressiveness of Japanese temple design.

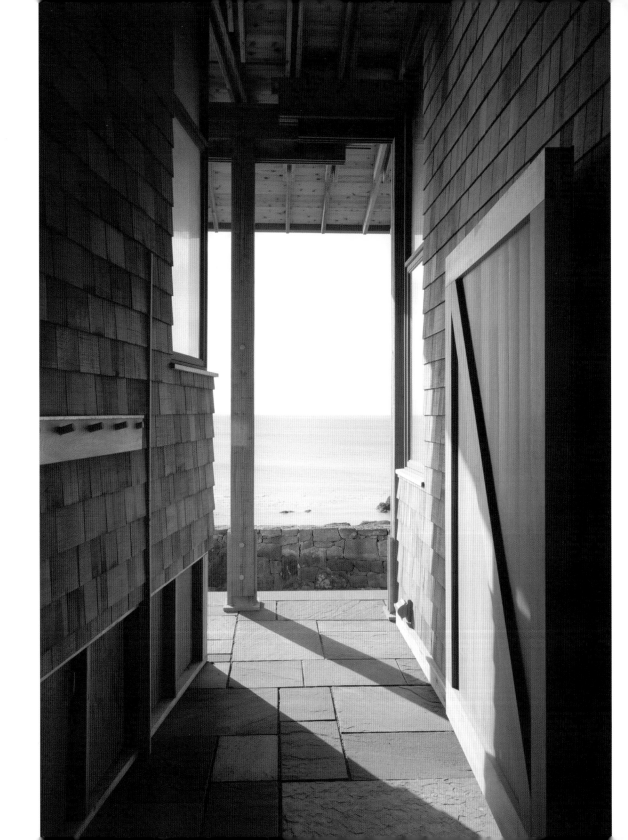

Reeve Residence
Lopez Island, Washington
(1999–2001)

This house is the finest example yet of Cutler Anderson's talent for creating a seamless fit between building and landscape. The pristine 120-acre site follows a mile of convoluted shoreline, running from vertical cliffs above Puget Sound to grassy terraces with protected bays. The 2,800-square-foot (260-square-meter) house nestles discreetly amid mossy outcroppings on a bluff between forest to the north and the Strait of Juan de Fuca to the south.

As wind travels across the 30 miles (48 km) of open water, it can whip up enough speed to shear off treetops along the cliff. To render the shed roof as inconspicuous and as streamlined as possible in the face of 70-mile- (112-km) per-hour winds, it has a low pitch matching the angle of the truncated treetops.

The sod-covered roof, supported by wood columns on a bluestone plinth, forms a pavilion that shelters the building's three independent volumes: a bunkhouse for children and overnight guests, a communal living area, and a master suite.

The design responds to the dual nature of this site—not only its windswept cliff side but also its more sheltering woodland side.

Approaching the house from the forest, glimpses of the watery horizon are visible through the spaces between the volumes. On this face, the house presents a classically proportioned but roughly hewn wood colonnade that mimics the surrounding trees and blurs the distinction between the house and the woods.

For openness and flexibility under 250 tons of sod, the structure is outside the volumes' exterior walls, allowing the positions of the bunkhouse and master suite to skew toward specific views. The family must travel outdoors to move between the parts of the house, but the heated stone plinth warms bare feet even in chilly weather, and the overarching roof, with its deep overhang, provides an umbrella.

The great room in the central block is a single open space with high windows that separate the white pine walls from the roof and give it the appearance of floating lightly overhead. Huge glass doors roll aside, opening up 16 feet (4.9 m) of the south façade to a generous stone terrace on the cliff overlooking the water.

BELOW ‖ **Site and floor plan; building section**

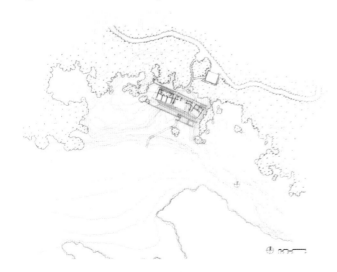

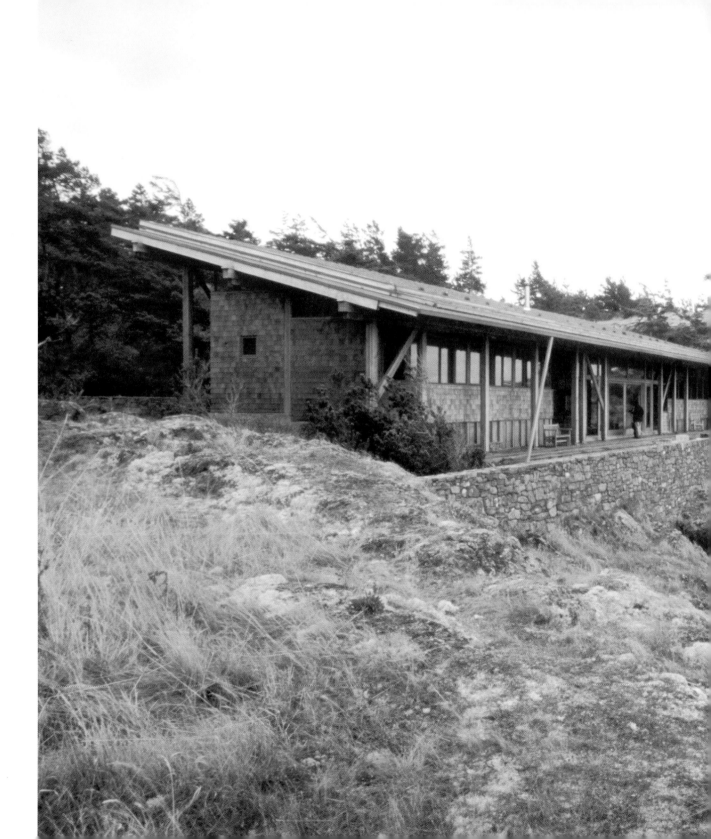

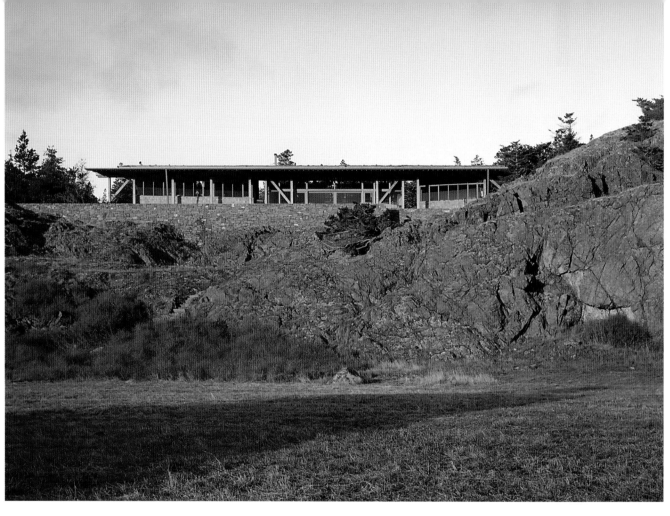

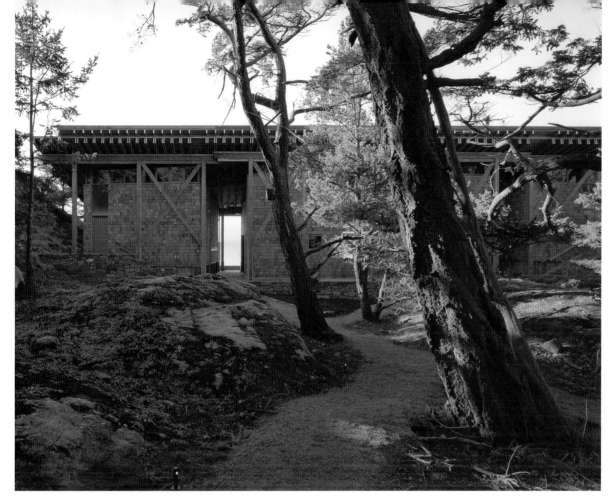

LEFT ‖ Viewed from the beach, 100 feet (30.5 meters) below, a basalt retaining wall blends with the cliff like an ancient Native American ruin.

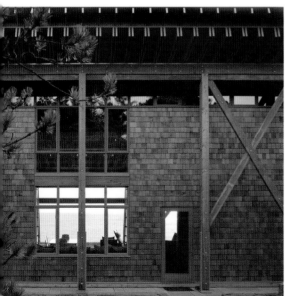

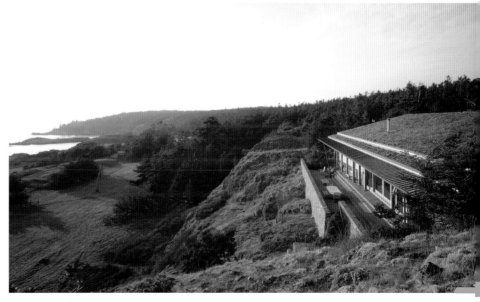

OPPOSITE ‖ The columns holding up the sod roof are independent of the walls allowing the bunkhouse and master suite to angle toward specific views.

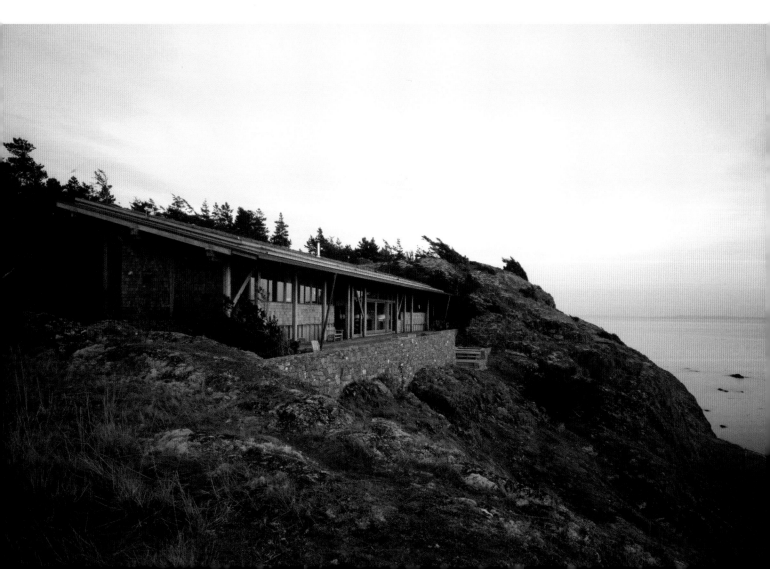

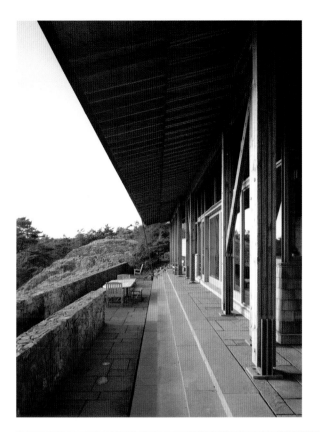

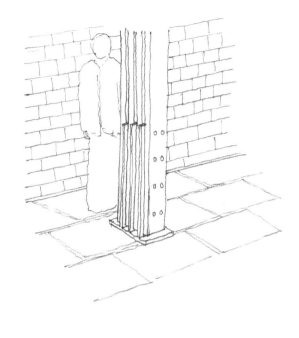

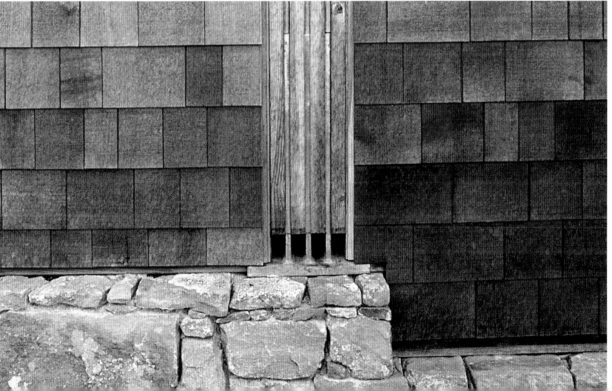

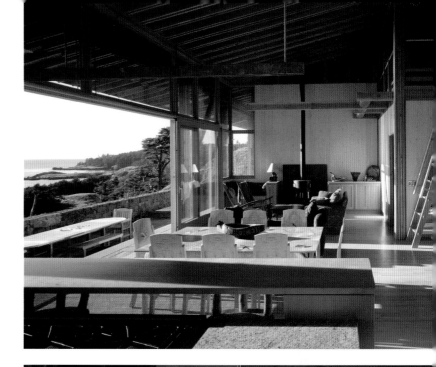

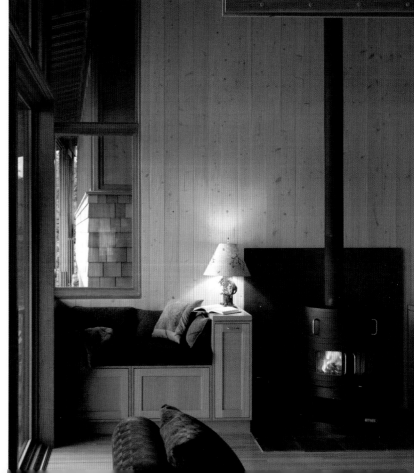

LEFT || Spaces between the volumes frame
coastal views. Throughout the house, the
columns and structural beams combine wood
studs and steel plates.

Reeve Residence / 73

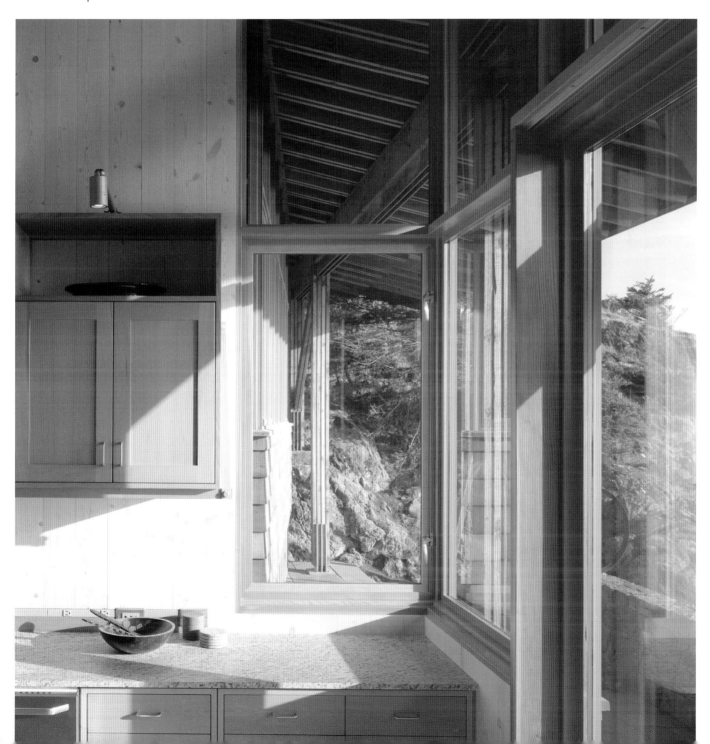

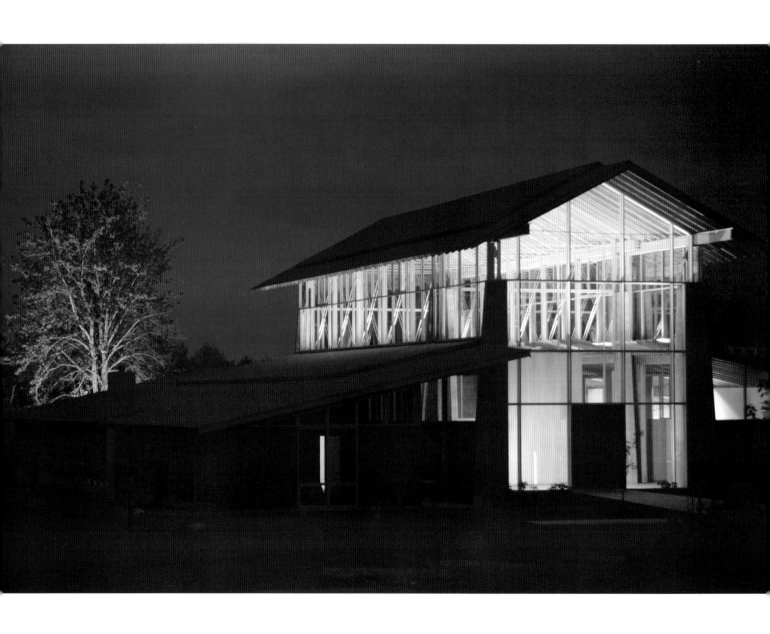

Grace Episcopal Church
Bainbridge Island, Washington
(1998–2003)

The transition from the secular to the spiritual begins with a view from a gravel drive all the way through the church to a big leaf maple on a hillside. For years, the parishioners worshipped in a basement before buying 12 acres on Bainbridge Island for a new Episcopalian church. The land had been clear-cut a decade earlier and was overgrown with scotch broom and alder trees. A 100-foot (30.5-m)- diameter circle filled with alder trees is ringed by parking eliminating the big asphalt lot that typically greets parishioners. A path cleared through the center of the circle is aligned with the sanctuary and the maple tree beyond. Over time, the congregation will watch the woods grow up again around the church.

A glacial stone, green-gray with flecks of red, found on the land, greets parish-ioners outside the church. Honed on the top and back but otherwise left rough, it is now the baptismal font. A zinc strip that delivers water to the font runs down the side of the stone to a cross at the terminus of the sanctuary.

Parishioners pass through a forecourt defined by the two wings of the church. Classrooms are on the east side of the sanctuary, and social spaces and offices on the west. The wings also define an outdoor terrace on the south side of the sanctuary for gatherings after services. A stone memorial wall for interning ashes steps down toward the woods and the maple.

The church is minimalist in its materials—wood and concrete—but it has a Gothic richness and scale that comes from its structure and details. Pairs of 24-foot (7.3 m) -tall battered piers of concrete frame the narthex and the sanctuary and provide lateral stability in the otherwise open sanctuary. A king post truss runs between the piers and carries the sanctuary roof on its upper chord. The lower chord of the truss supports the edge of the low roof over the side aisles. The rafters over the side aisles continue into the sanctuary in a filigree of wood that modulates the scale of the 35-foot (10.7 m) - tall sanctuary. Like tracery, steel rods cross in front of the clerestory windows between the side aisle and sanctuary roof; the space is infused with natural light. For the parishioners who worshiped for years in a basement, the sanctuary's openness and connection to the natural world is a blessing.

BELOW ‖ **Site and floor plan**

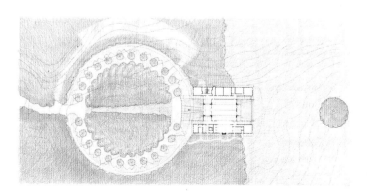

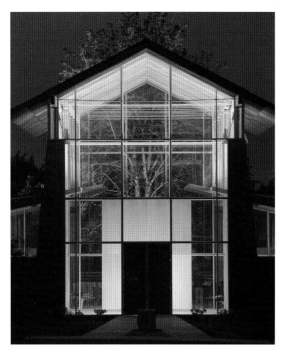

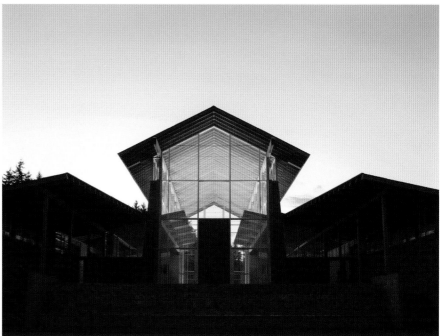

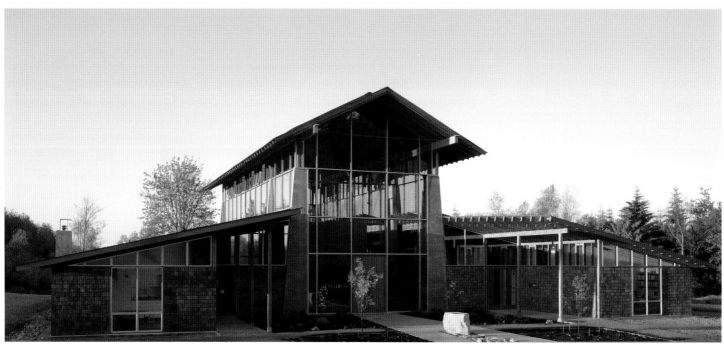

ABOVE ‖ Parishioners pass through a fore-court defined by the two wings of the church into the sanctuary.

BELOW ‖ A zinc strip runs from the glacial stone baptismal font at the front of the church to a cross at the altar.

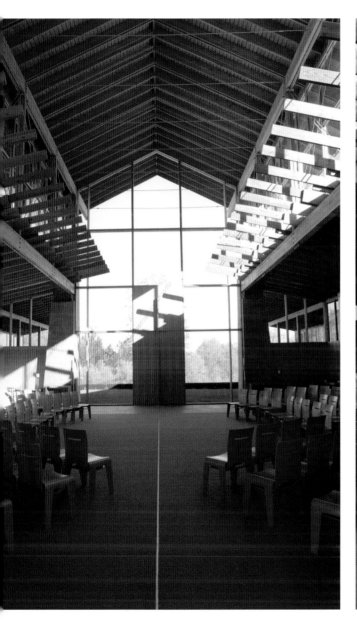
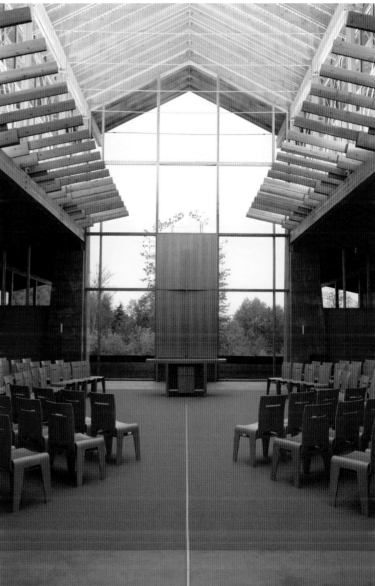

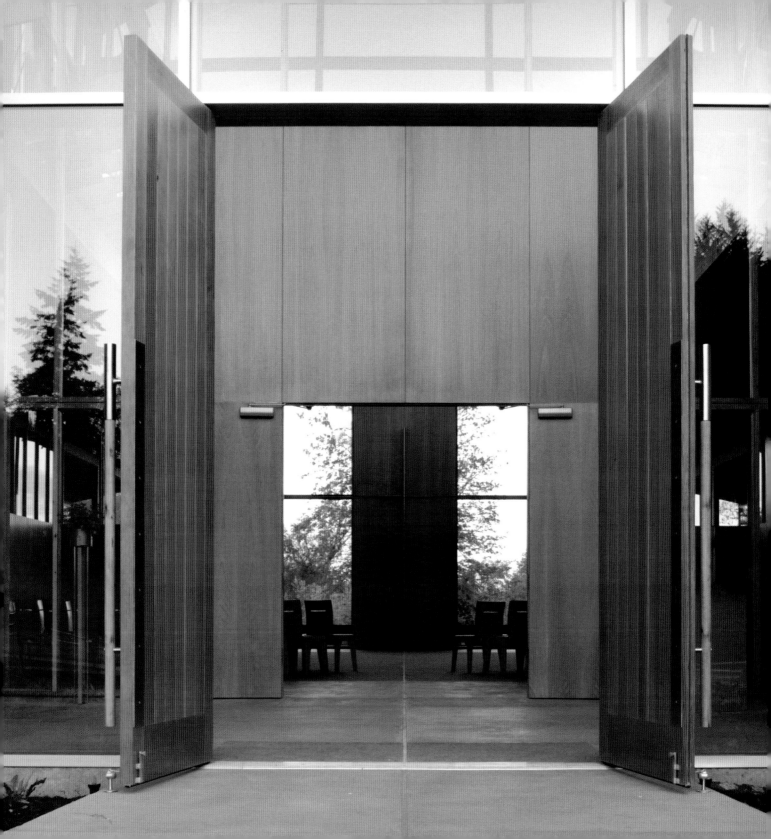

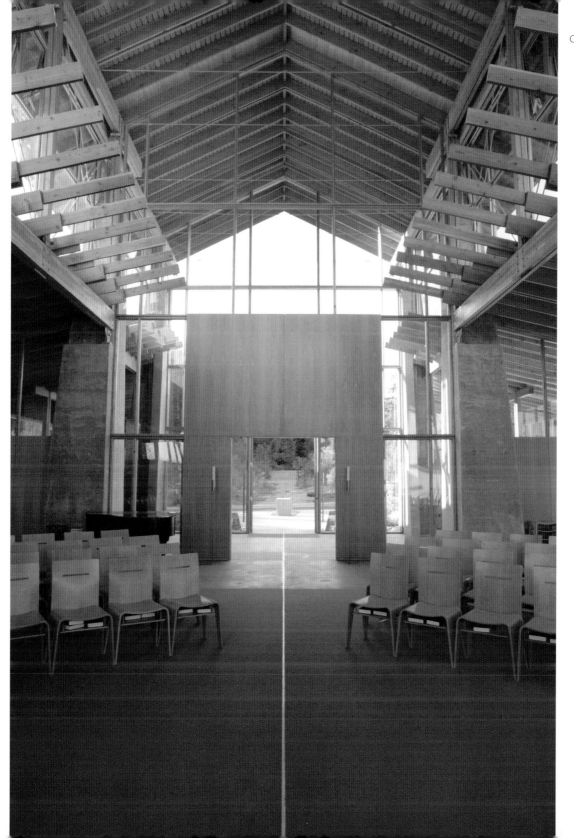

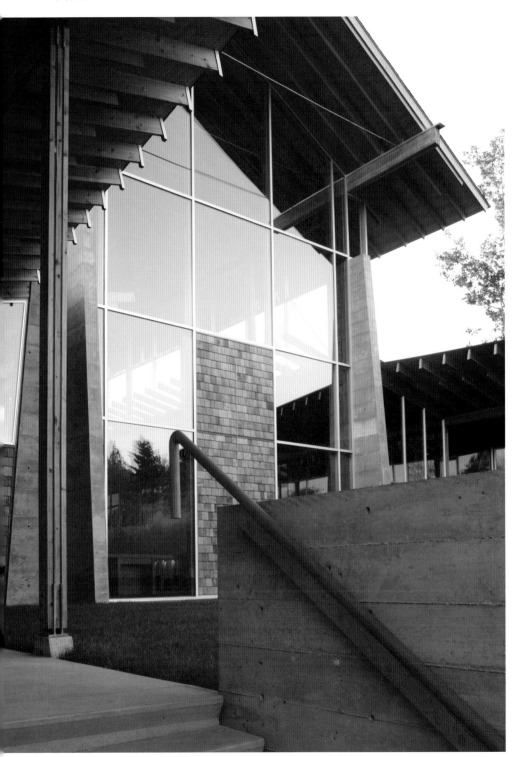

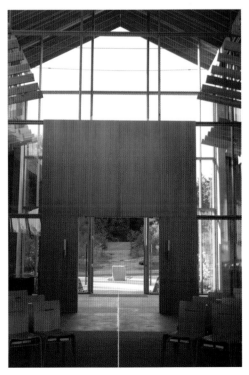

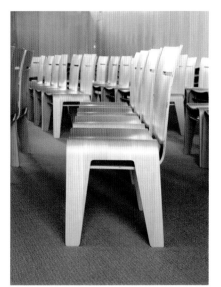

RIGHT ‖ The beech-veneer chairs, custom-designed by Cutler Anderson for the church, are two planes of bent plywood folded to create a shelf for a kneeler under the seat.

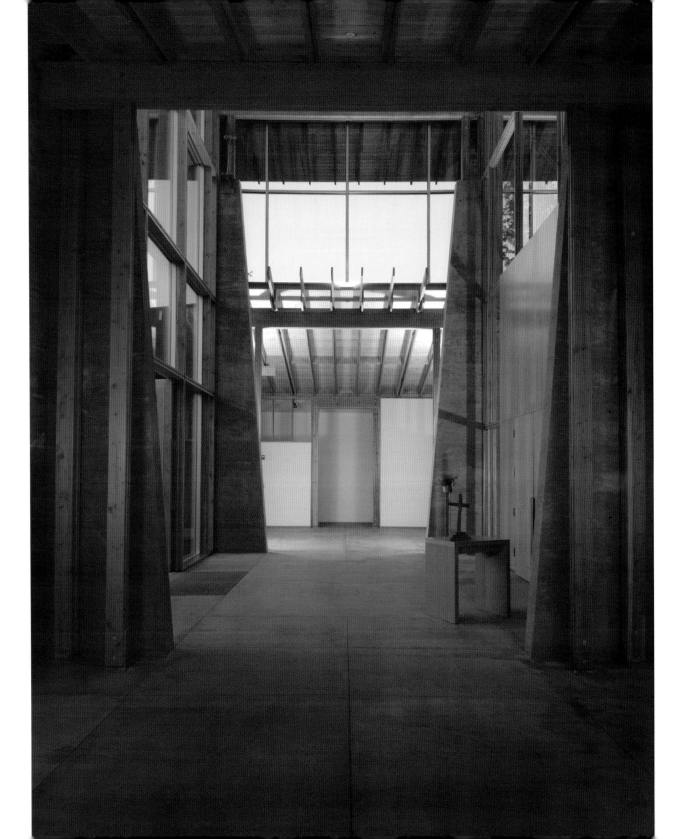

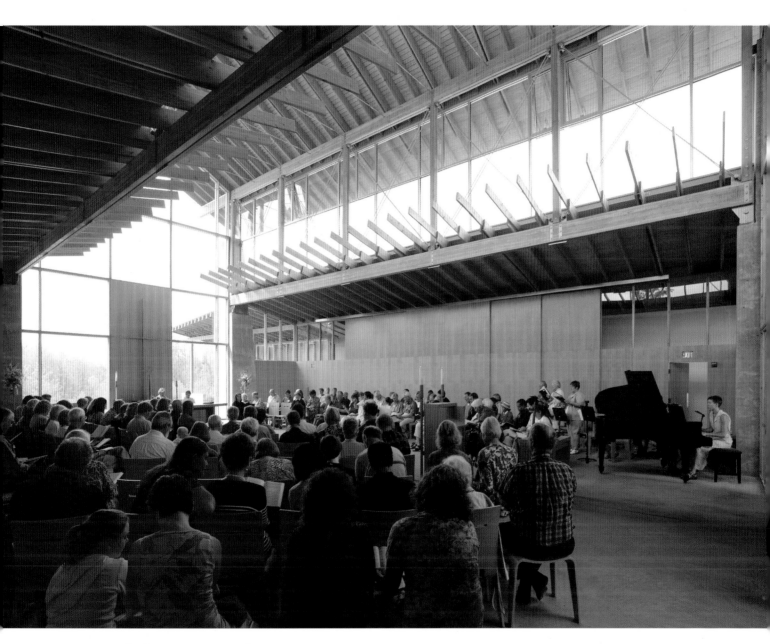

ABOVE ‖ A king post truss carries the sanctuary roof on its upper chord. The lower chord supports the roof over the side aisles.

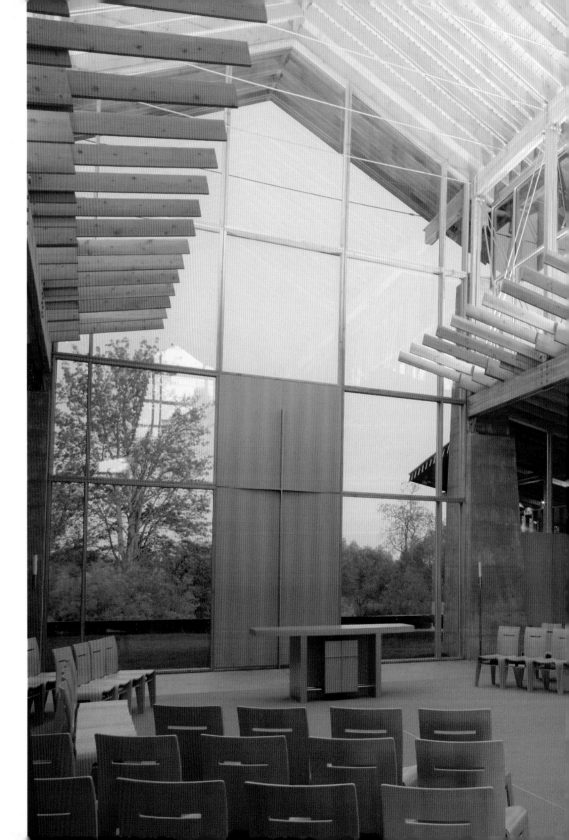

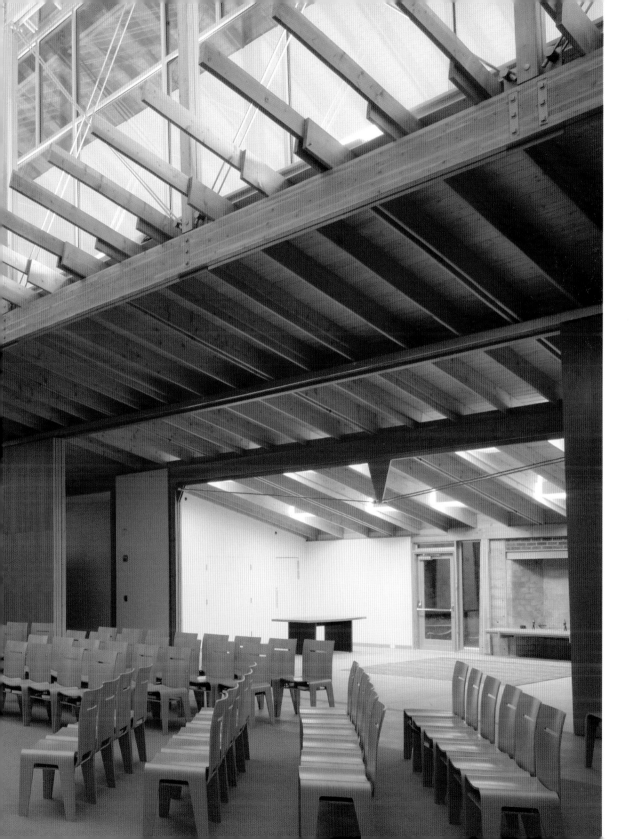

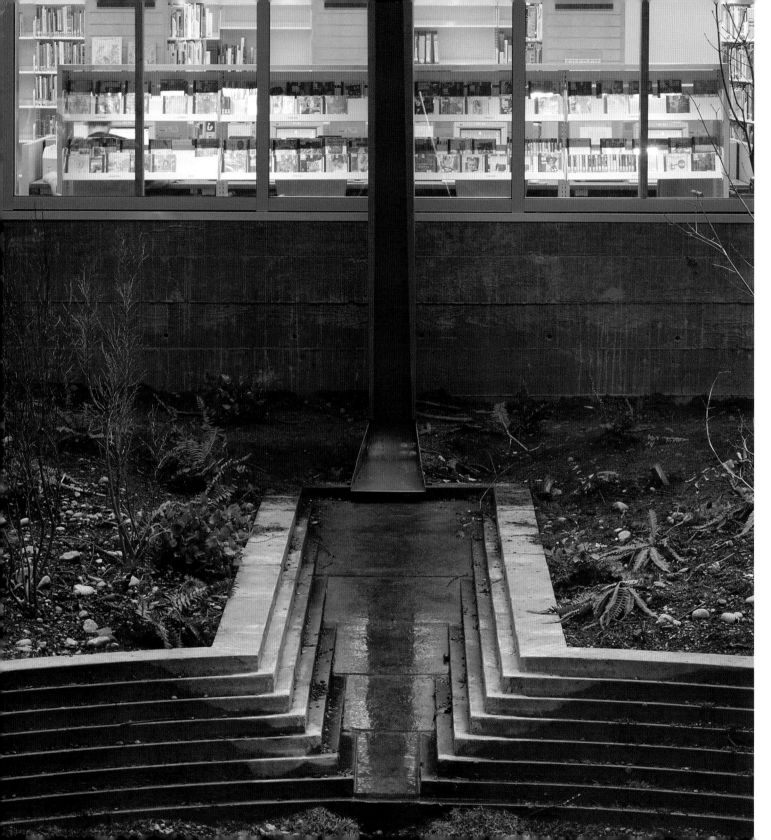

Maple Valley Library
Maple Valley, Washington
(1999–2001)

Most of the trees that gave Maple Valley its name are gone, but the design of this small branch library shows that buildings and forest can coexist. Working from arborists' detailed plans, the designers tramped through the dense understory of vine maple, salal, and fern to fine-tune the parking and the building to the land. Instead of a large asphalt lot, parking spaces slip in small clusters between tree trunks, as at a campground. In contrast to the meandering parking layout, the design of the 12,000-square-foot (1,115-square-meter) library (made in collaboration with Johnston Architects) is crisp and rational. Its simple, rectangular shape is the most efficient use of materials; the design honors wood by not wasting it and meets the modest $1.8 million budget.

The U-shaped library has a metal shed roof that is highest along the perimeter of the building and slopes down toward a central courtyard. This minimizes the height of the library on the forest side while presenting a crown of softly glowing windows at the eave along the street. During storms, the roof funnels rainwater to a downspout that pours into a sculptural pool in the courtyard. This dramatic display is both poetic and functional, demonstrating the runoff urban development creates while filtering stormwater through the gravel bottom of the pool.

From a porch, visitors enter directly into the main reading room. Its scale and proportions, 50 by 140 feet (15 m by 43 m), give it the stateliness of a classic Carnegie library reading room. A simple space, its power lies in the expressiveness of the exposed structure. Windows are fixed to the outside of the framing and the floor-to-ceiling wood studs are visible through the glass, melding the structure with the tree trunks outside. The children's reading area in the north corner looks onto large firs and ancient stumps, while the adults' area on the south overlooks a cluster of vine maples. At night, the large windows glow like a lantern for a welcoming civic presence that also strongly connects to the outdoors.

BELOW ‖ **Site and first-floor plan**

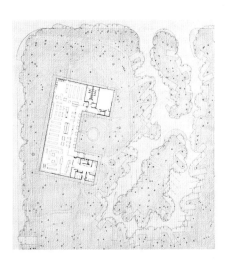

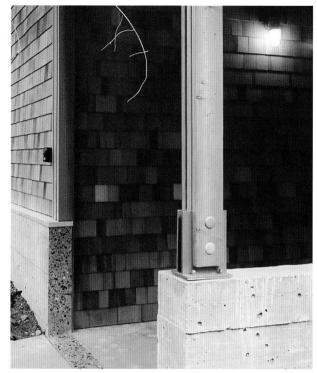

RIGHT ‖ A 3-foot (0.9 m) -high concrete wall provides a solid base from which the wood stud walls rise from the forest floor. The wall's rustic surface makes the library look like it was built on the foundation of an old, abandoned building reclaimed by the forest.

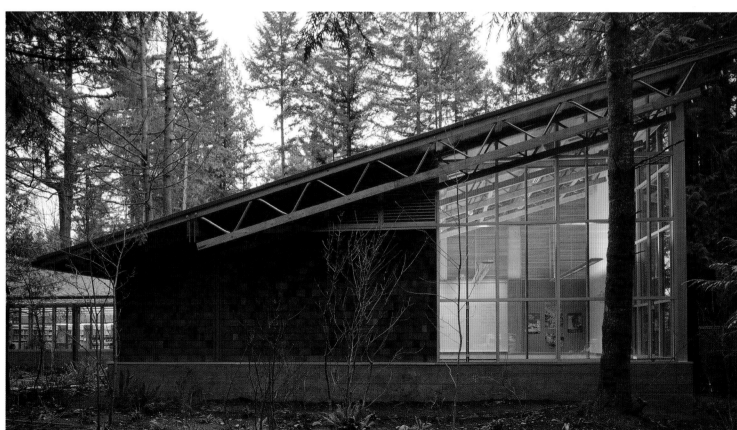

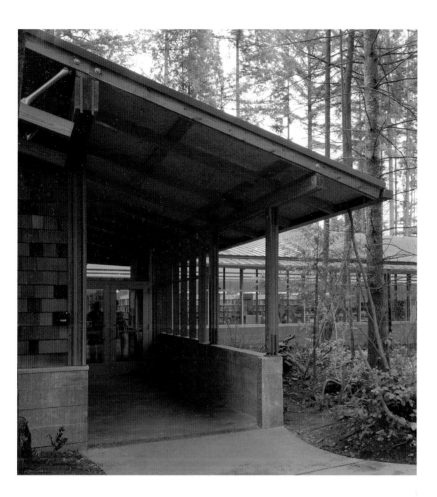

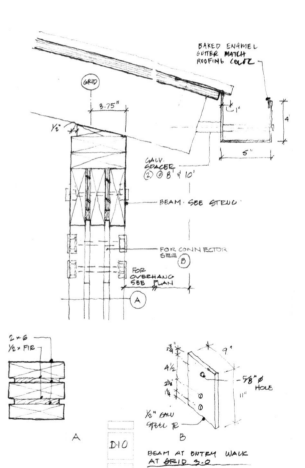

BAKED ENAMEL
GUTTER MATCH
ROOFING COLOR

GRID

3.75"

½"

1"

4

5"

GALV.
SPACER
(2) @ 8' & 10'

BEAM· SEE STRUC.

FOR CONNECTOR
SEE B

FOR
OVERHANG
SEE PLAN

A

2 × 6
½ × FIR

A

D·10

¾"

9"

4½

2½
1¾

⁵∕₈" Ø
HOLE

11"

½" GALV
STEEL PL

B

BEAM AT ENTRY WALK
AT GRID 3.0

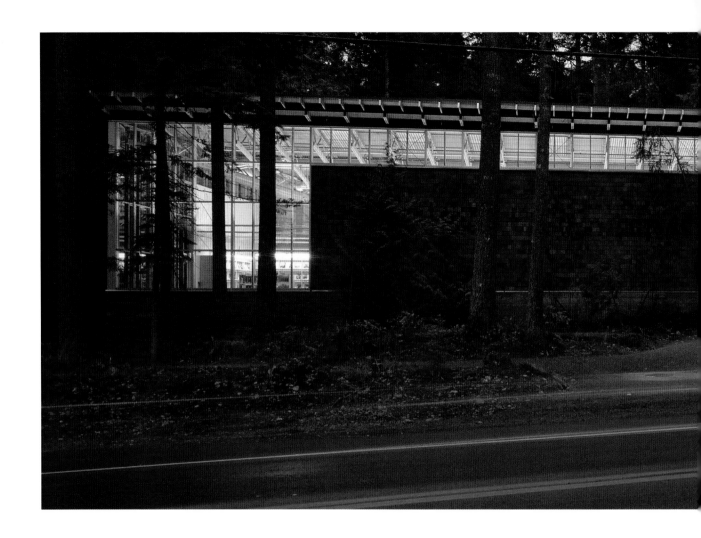

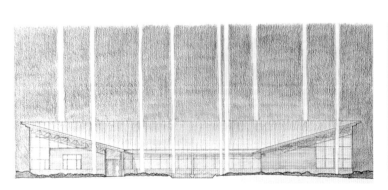
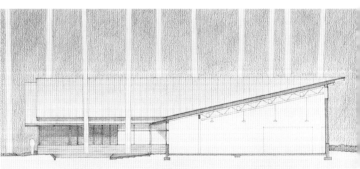

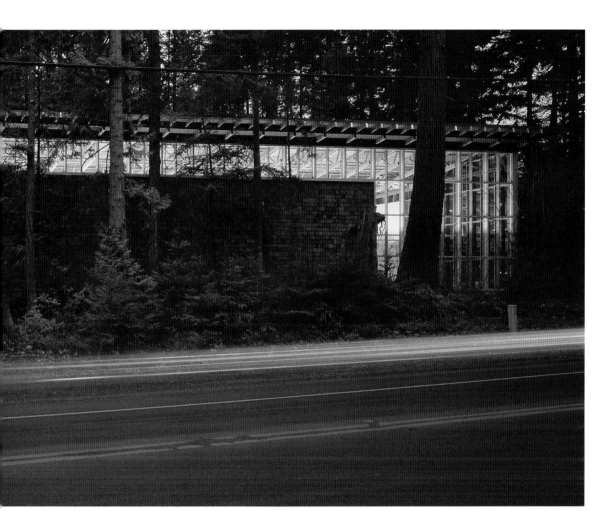

ABOVE ‖ Maple Valley Library's wood and glass conveys a civic presence while forging a strong connection to the outdoors.

RIGHT ‖ East elevation

OPPOSITE, FROM LEFT ‖ West elevation; building section

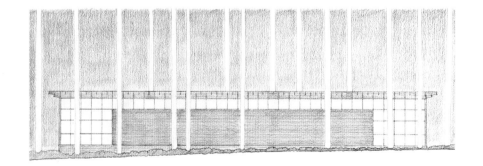

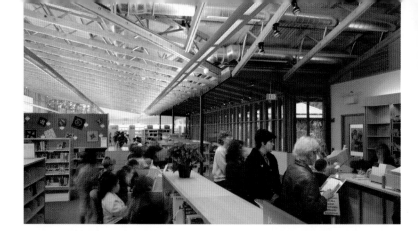

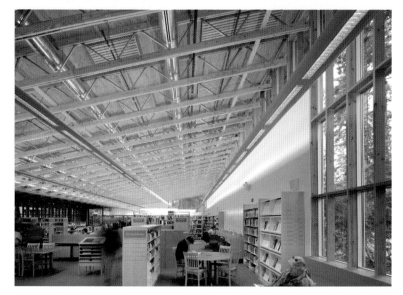

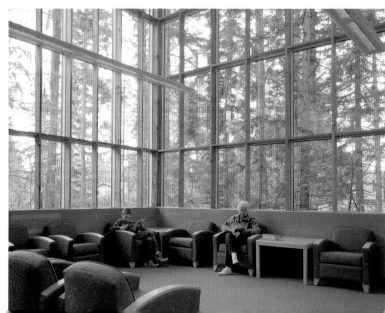

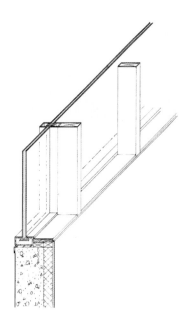

ABOVE ‖ Isometric of windows and exposed wood framing.

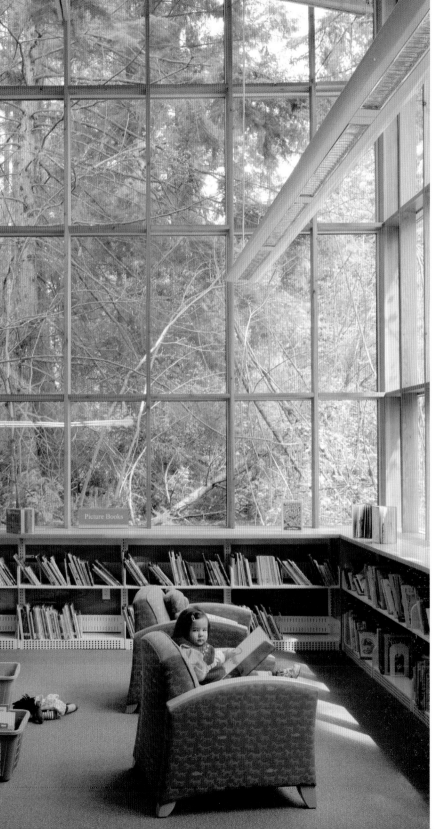

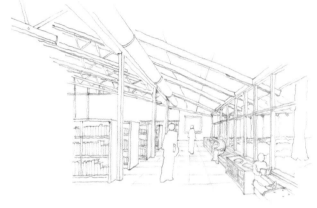

LEFT ‖ A rhythm of exposed 2-by-6 wood studs circles the room. Window frames are fixed to the outside of the frame so the floor-to-ceiling wood studs are visible through the glass, blurring the boundary between interior and exterior.

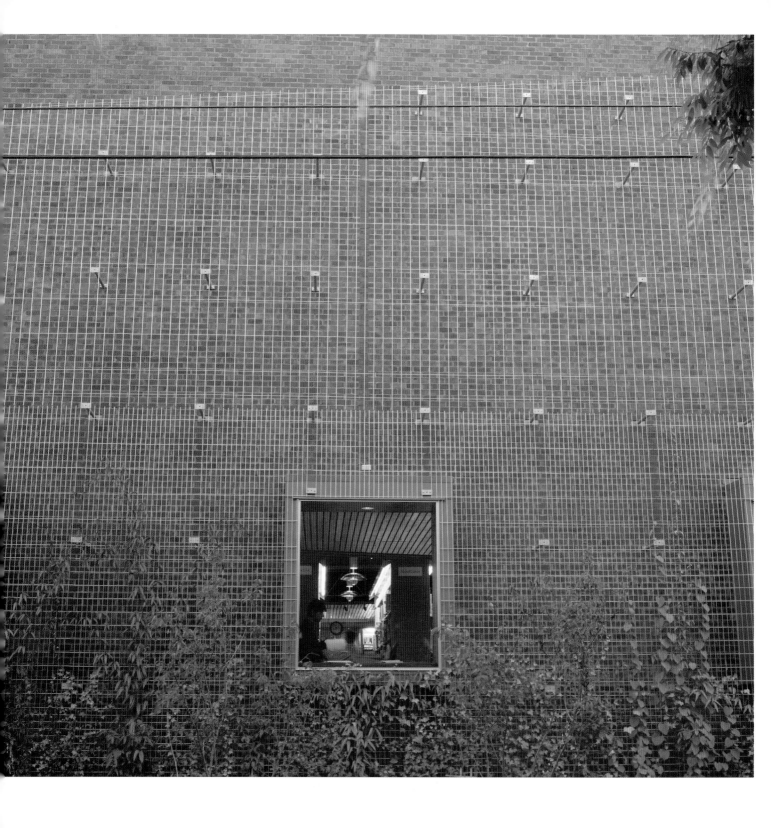

Capitol Hill Library
Seattle, Washington
(2000–2003)

This new branch library provides a place of refuge in Seattle's most densely populated urban neighborhood. It replaces an undersized 1954 library on the same spot, a block away from the neighborhood's main shopping street. Without enough space for a conventional garden on the small corner lot, Cutler Anderson with Johnston Architects covered the brick walls with trellises planted with nineteen varieties of vine to create a vertical hanging garden.

At 88 by 86 feet (26.8 m by 26 m), the new 11,615-square-foot (1,079-square-meter) library is almost a perfect square in plan. A V-shaped opening slices through the two-story building at the angle of the sun at winter solstice and defines a double-height reading room with a wall of windows on the south elevation. A large triangle of metal roof covers the reading room, beginning over a reading porch outside the large south-facing windows, and slopes to a point 38 feet (11.6 m) above the sidewalk over a triangular prow of trellis that marks the main entrance on the north.

The bricks were tumbled to age them so they would fit with the historic brick apartment building to the south. The mortar was trowel struck to give the walls a monolithic quality. The metal trellis is held off the wall on short aluminum legs and is interrupted by a large bay window containing reading nooks. The trellis wraps the brick walls and continues the green wall inside the library. Artist Iole Alessandrini's lighting installation behind the trellis makes the green walls glow at night.

At the street intersection, a two-story window turns the corner and resembles a book-filled lantern. A ramp leads up from the corner to the midblock entry within the triangular trellis. Inside is a double-height reading room framed by administration spaces, meeting rooms, and offices. A thin strip of skylight separates the wedge of sloped roof from the brick walls and appears to float overhead. Library patrons pass under a bridge that links a community meeting room to a neighborhood service center on the second-floor mezzanine and into the generous light-filled reading room.

BELOW ‖ **Site and floor plan.**

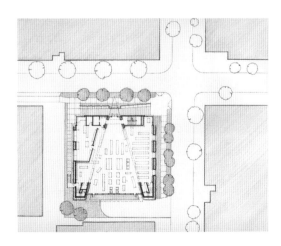

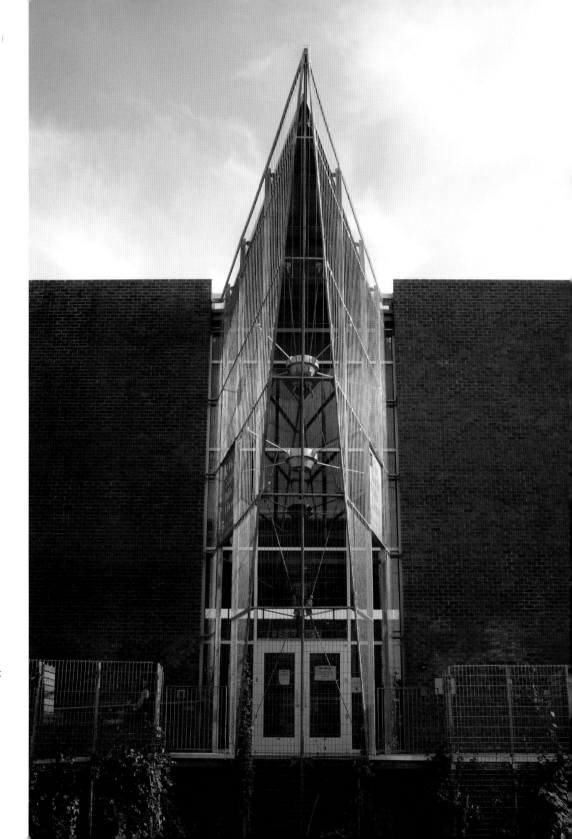

RIGHT ‖ Lighting by artist
Iole Aessandrini will make
the ivy-covered entrance
glow at night.

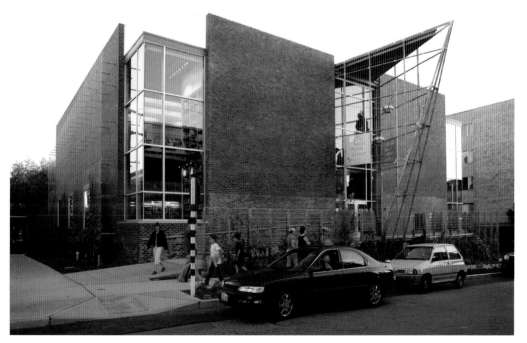

LEFT || A trellis wraps the brick walls and into the library to create a vertical garden in a dense urban neighborhood.

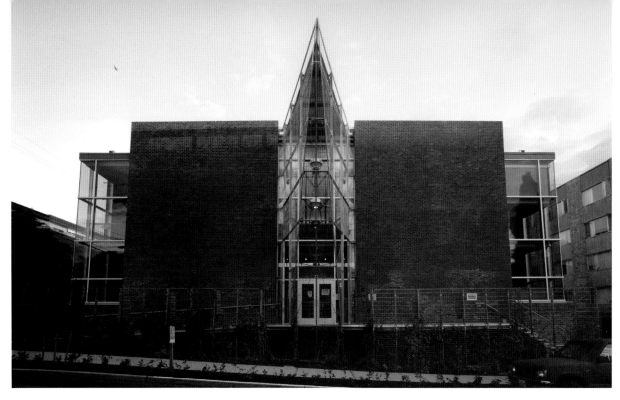

RIGHT ‖ The trellis will soon disappear under nineteen varieties of ivy.

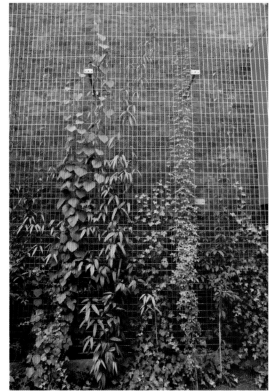

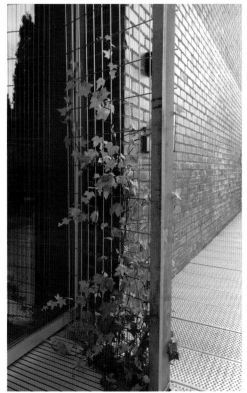

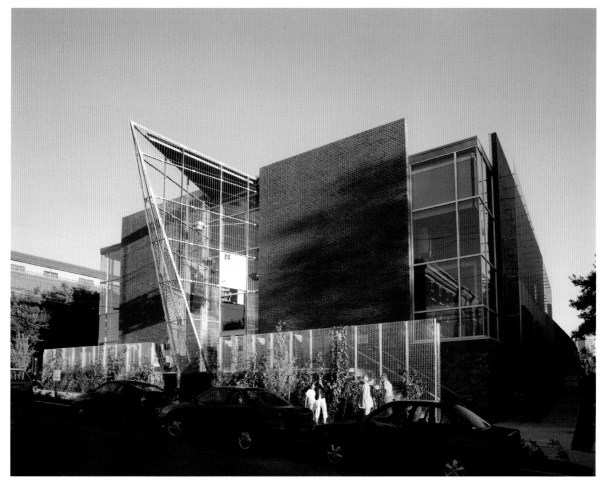

LEFT ‖ Ivy-covered trellis will screen the benches at the entrance from the street.

BELOW ‖ Large bay windows contain reading nooks along the street.

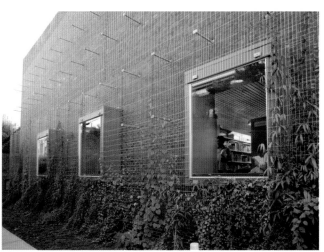

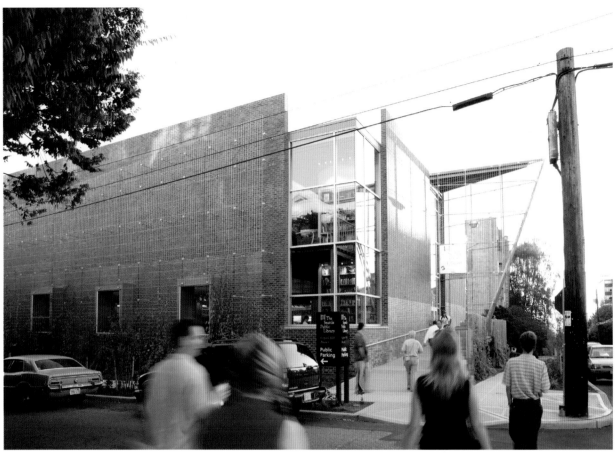

RIGHT ‖ A triangular metal prow of trellis marks the main entrance.

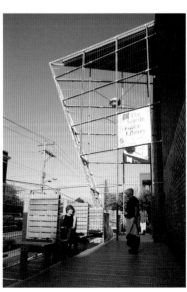

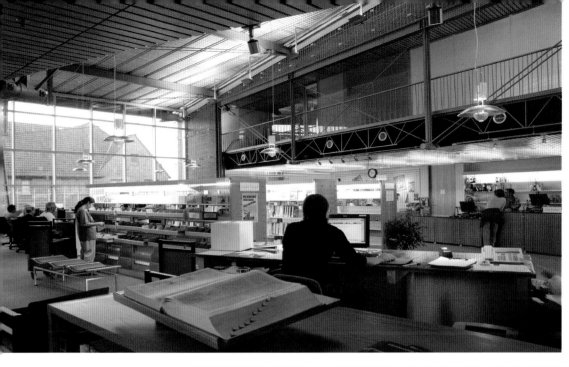

BELOW ‖ A V-shaped opening slices through the library defining a double-height reading room covered by a triangle of metal roof. The roof slopes up from a reading porch outside large south-facing windows to the triangular prow of trellis at the entry.

RIGHT ‖ The ivy-covered trellis continues inside the library and will cover the brick walls in a blanket of green.

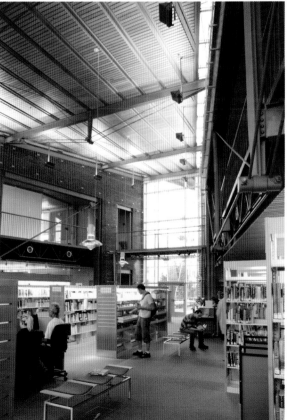

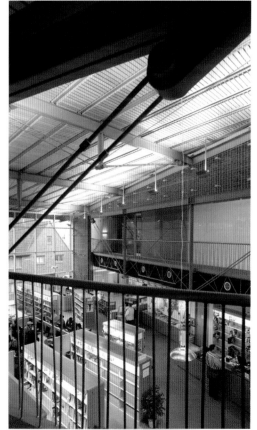

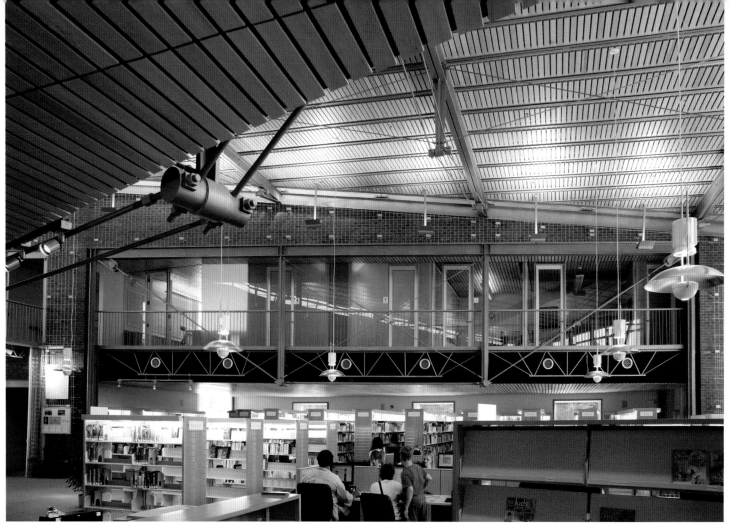
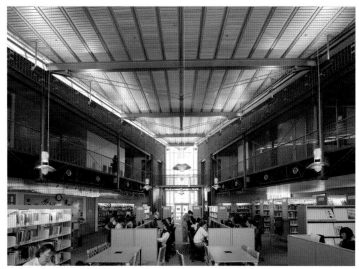
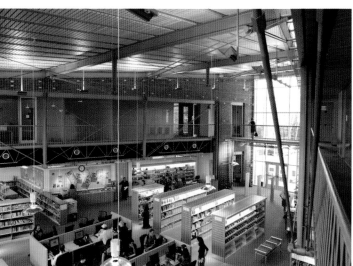

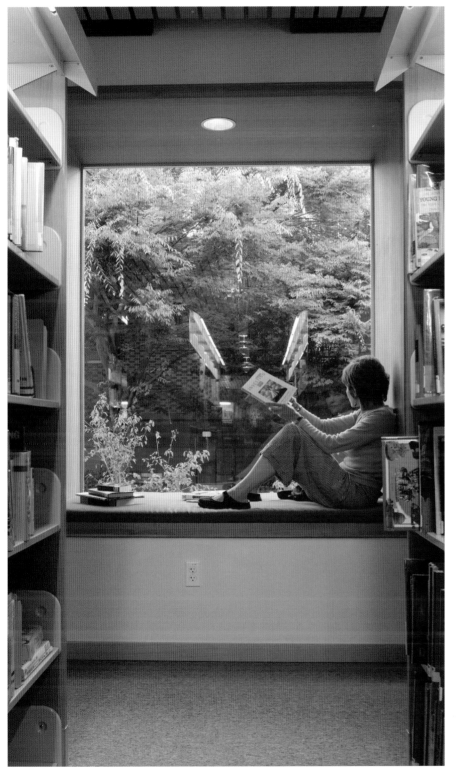

LEFT ∥ The library provides an oasis in one of Seattle's densest urban neighborhoods.

Long Residence
Orcas Island, Washington
(2000–2003)

This retreat on Orcas Island along the Harney Channel has a view of the green and white Washington State ferries as they ply their watery route among the San Juan Islands. The house is on a shallow south-facing strip of land along the narrow waterway with a tombolo—a rocky islet connected to the main island by a spit of sand—completing the scenic picture. There is little fetch (the amount of open space on water where wind builds up), allowing the roof to pitch up toward the water without fear of a gale ripping it off.

The design of the house is all about supporting the roof. Because most people experience wood as sawn lumber, the house is an opportunity to underscore the raw beauty and power of trees in their more natural state. Western red cedars were harvested from the contractor's father's land and then water-blasted to remove the bark and reveal their skeletal form. The six logs, between 12 and 60 feet (3.7 m and 18.3 m) long, are hoisted in the air on bundled tripods of cedar poles.

The logs and beams sit on a simple rectilinear concrete platform that retains earth on the north side of the house and forms a large terrace on the south, where the steep hillside slopes down to the water. The longest log runs parallel to the north wall of the house along the forest and supports the low edge of the roof as it slopes up to 15 feet (4.6 m) along the water. Three logs sit at a slight angle to each other along the south to form a seg-mented arch that captures a view of the channel. A glass wall with large panes and few mullions sits outside the structure, wrapping it on three sides.

Visitors arrive through the woods along the north edge of the house, which is nestled into the forest floor. A series of small windows in the otherwise opaque wood-shingled façade frame vignettes of the wood tripods inside. A retaining wall extends into the hillside and holds back earth at the front door. The entry is into a low enclosed area that widens as the ceiling slopes up over the main living dining area with the channel beyond.

BELOW ‖ **Site and floor plan**

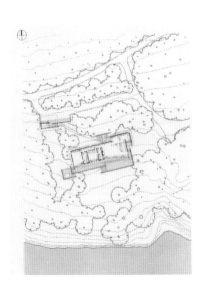

BELOW ‖ A glass skin wraps a skeletal structure of peeled cedar logs held aloft on bundled log tripods.

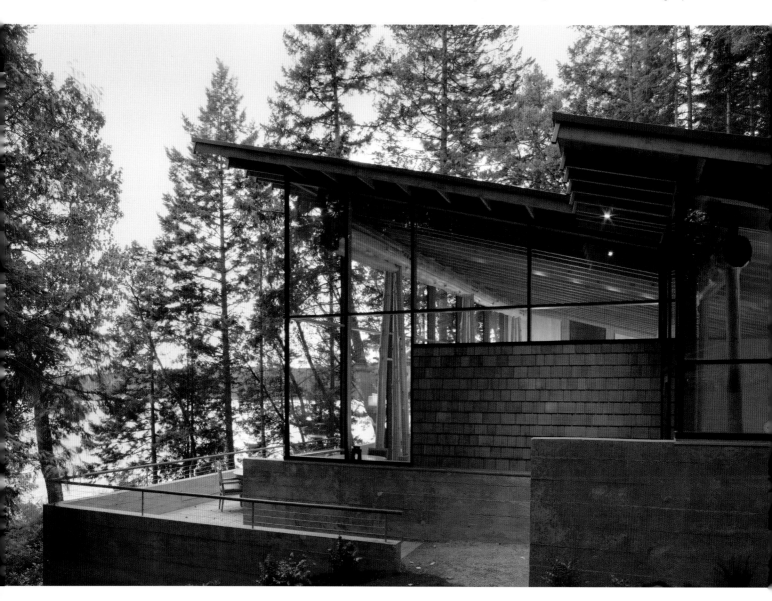

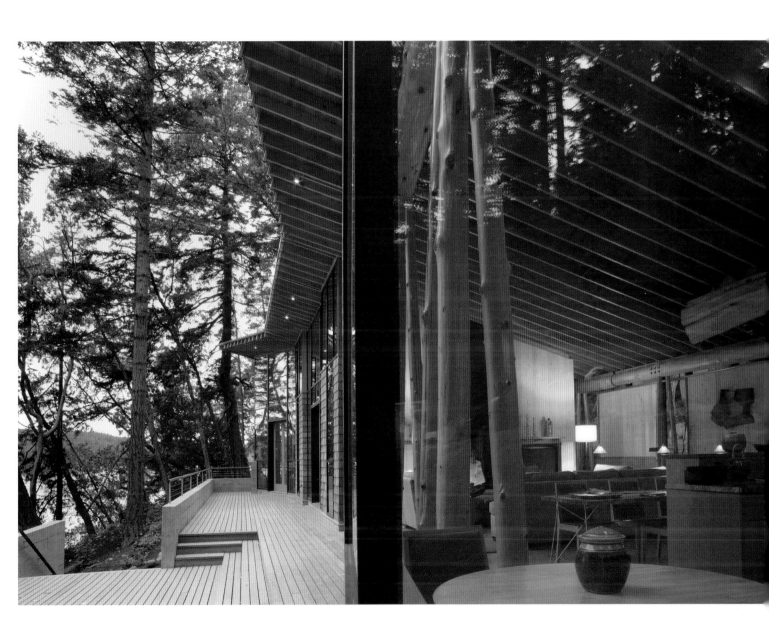

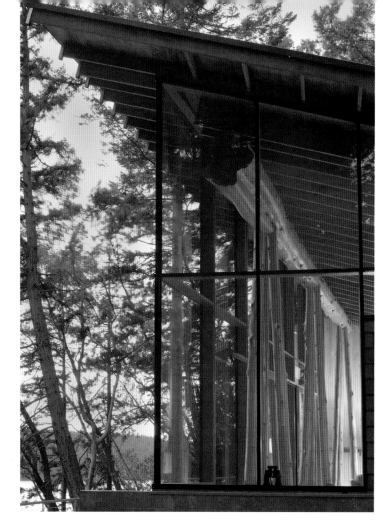

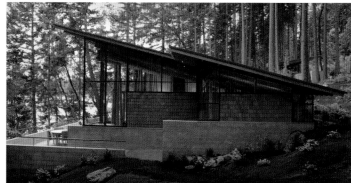

BELOW ‖ The roof is lower above the entry on the north and slopes up above the main living-dining area along the channel.

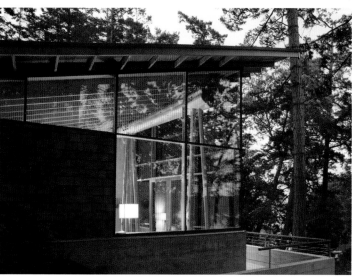

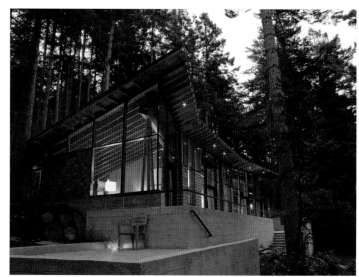

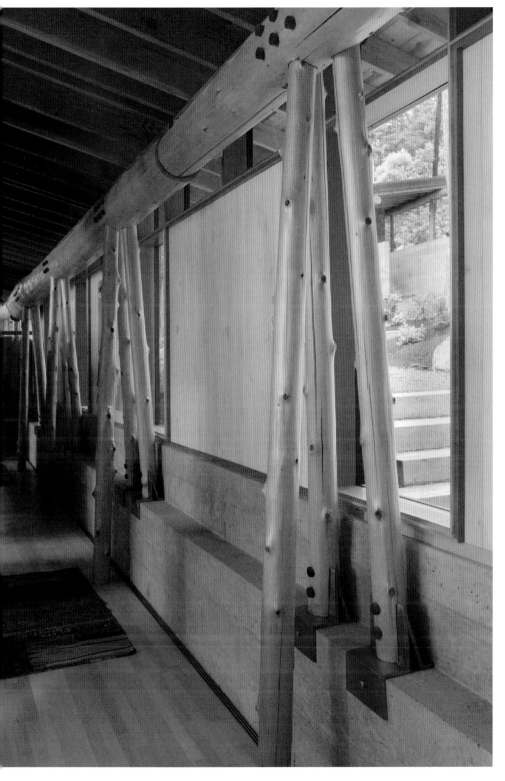

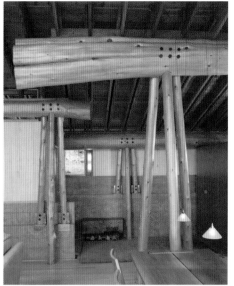

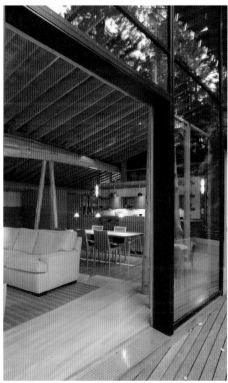

LEFT ‖ The wood tripods resist lateral loads and express structural stability.

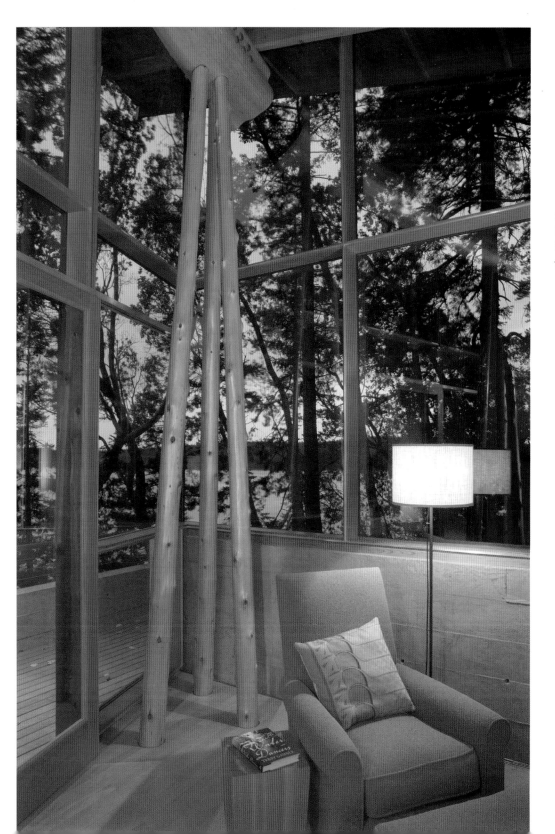

LEFT ‖ The peeled cedar logs inside underscore the beauty and power of the trees outside.

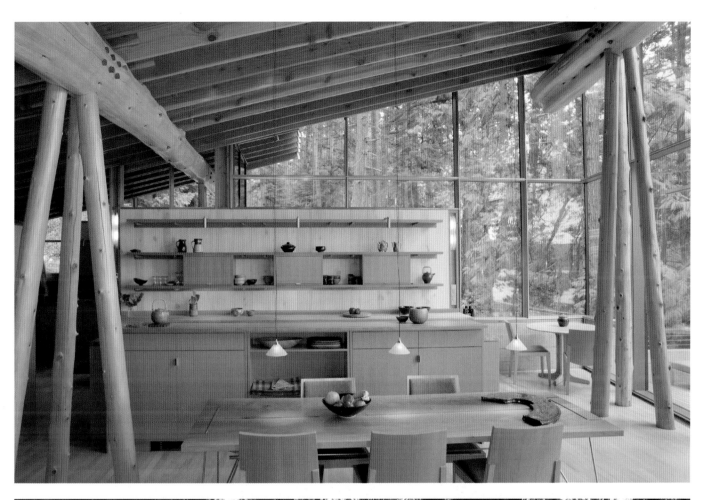

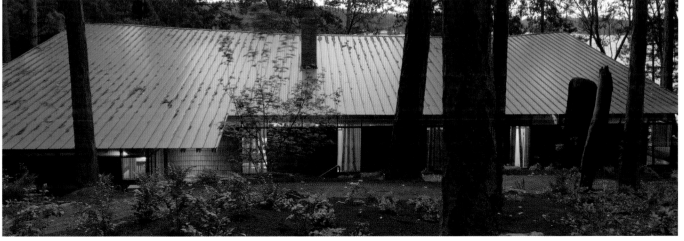

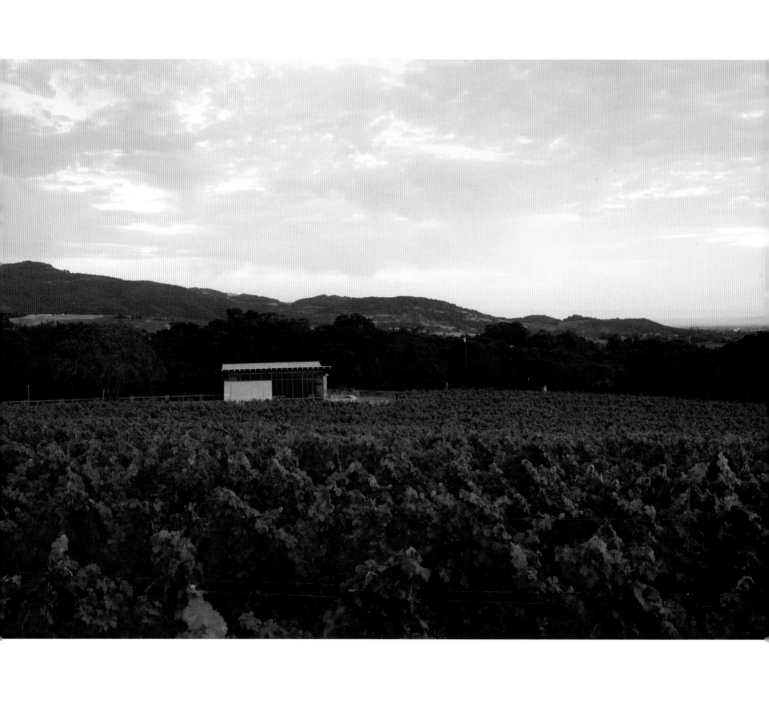

Residence at Meteor Vineyards
Napa Valley, California
(1999–2003)

Study

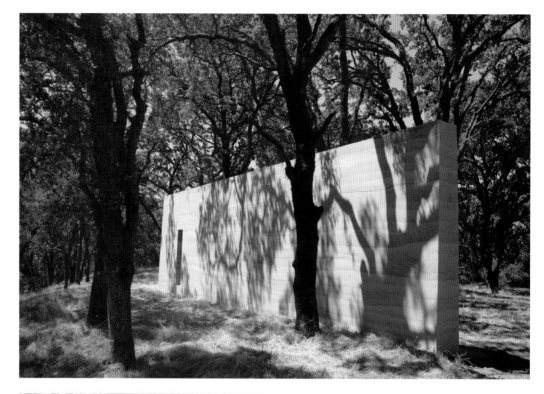

RIGHT || The study's rammed earth walls define an L-shape enclosure among the oaks.

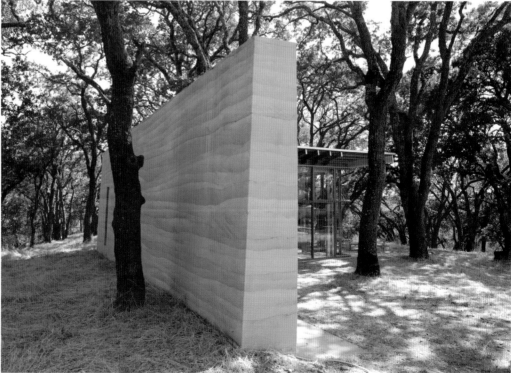

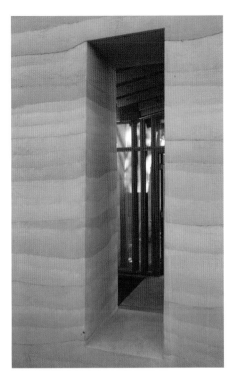
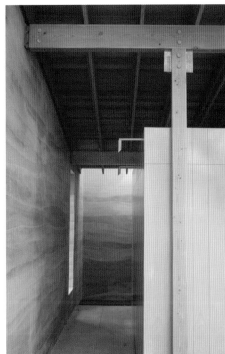

BELOW ‖ A variety of soils from the surrounding hills create marbled layers in the rammed-earth walls.

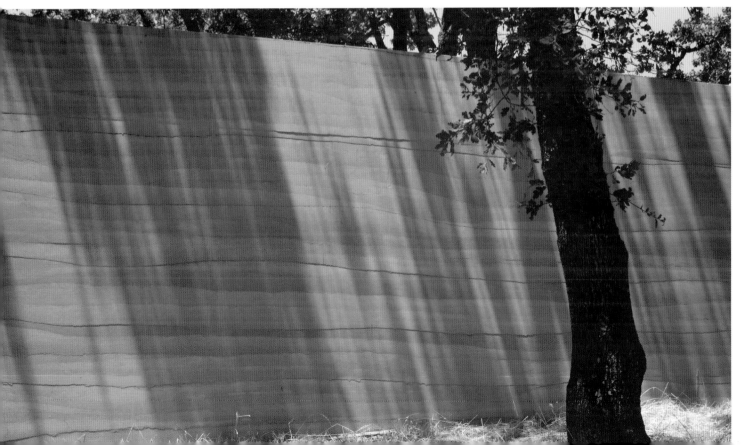

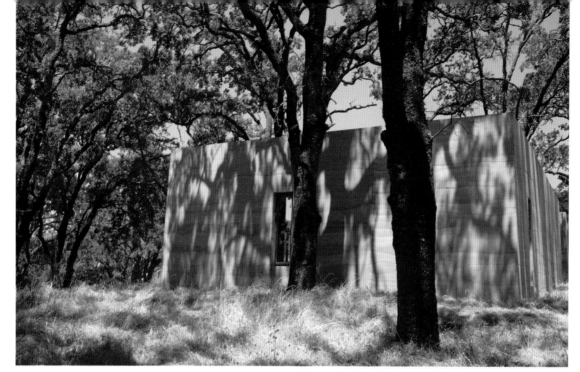

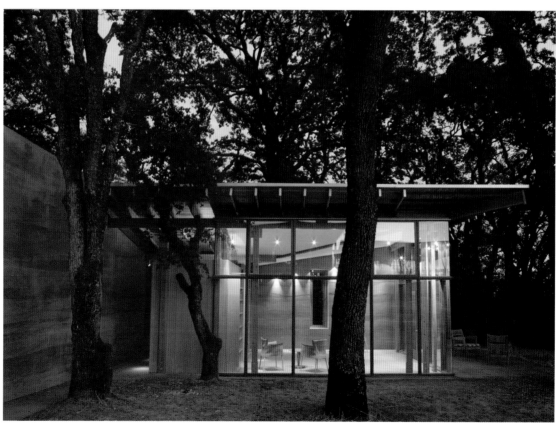

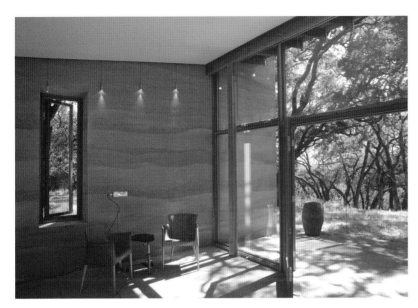

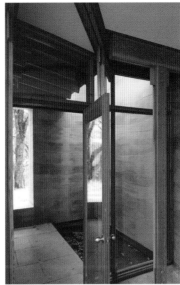

LEFT ‖ Rainwater from the roof pours into to a small pool near the study's entry.

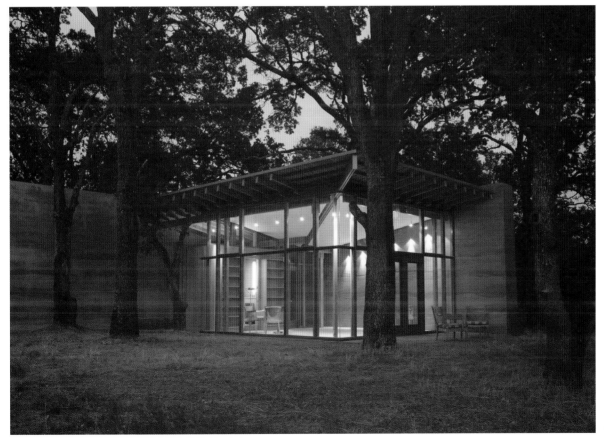

LEFT ‖ The study is a single open space with glass walls opening to views of the gnarled oaks.

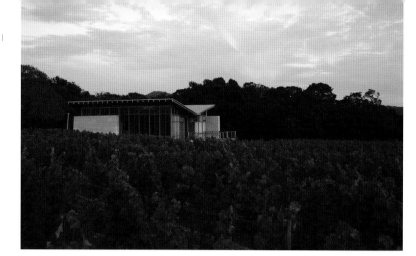

Guest House

RIGHT ‖ A bridge from the main house to the guest house floats above the ground for a knee-high walk among the vines.

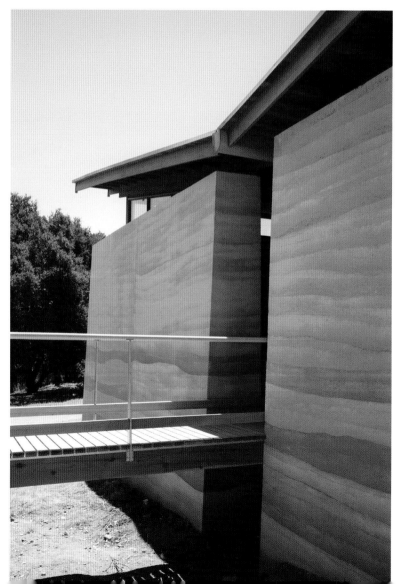

OPPOSITE ‖ French doors punctuate the guesthouse's rammed-earth wall at each of the three private suites.

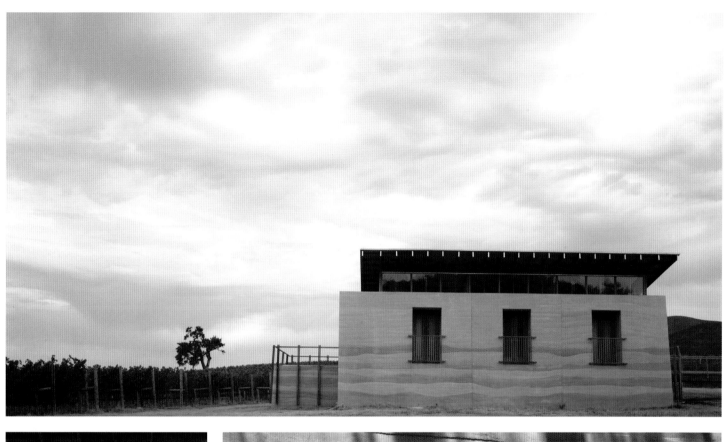

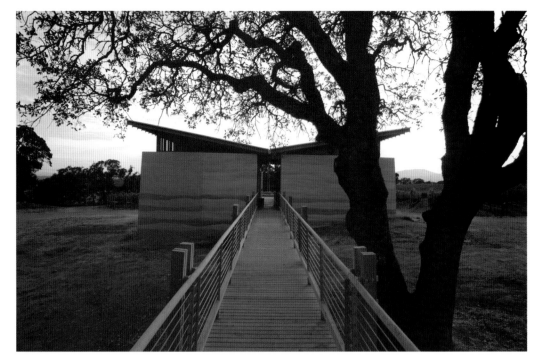

RIGHT ‖ The axis from the main house terminates in a pool (on the west side of the guest house) filled by rainwater off the V-shaped roof.

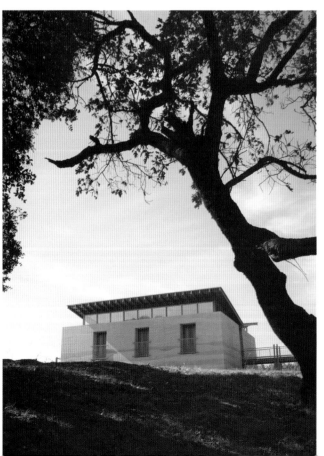

BELOW ‖ The guest suites share an open living and dining area with views of the vineyard.

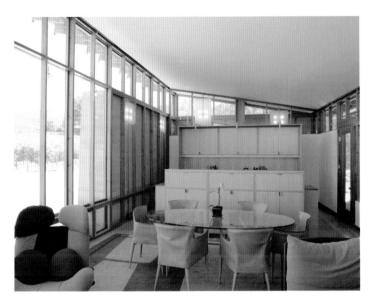

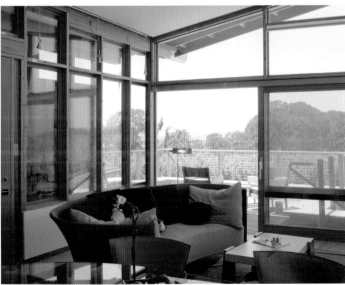

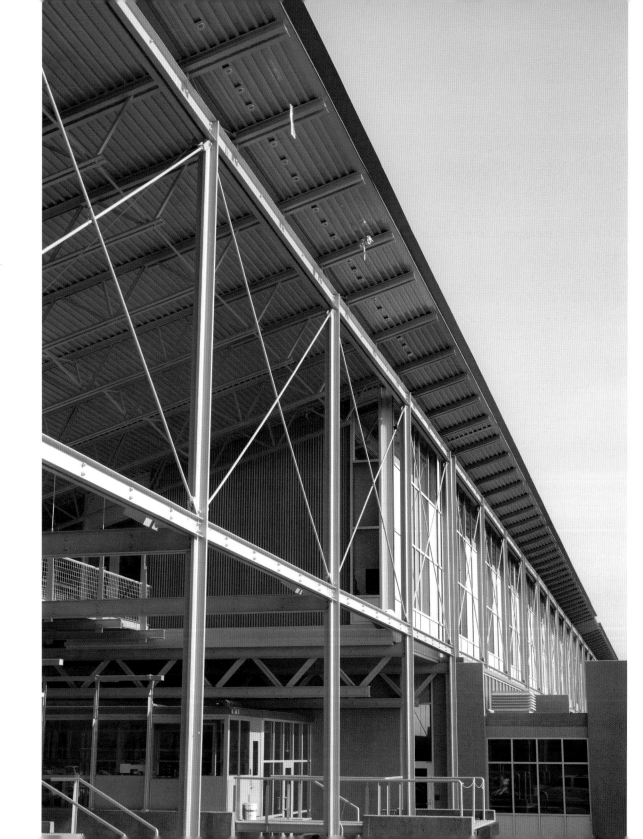

A New Joint Port of Entry
Oroville, Washington, and Osoyoos, British Columbia
(1994–2004)

This border crossing between the United States and Canada is one of the first new shared facilities built since the enactment of the Joint Border Accord of 1995. The only port of entry in the region, it serves a major arterial highway between eastern Washington and British Columbia. Due to its important location, it provides twenty-four-hour service for both noncommercial and commercial vehicles and processes high-risk cargo. The design uses the roads and new trees to reveal the natural beauty of the surrounding landscape.

The crossing is near Lake Osoyoos, 19 miles (30.6 km) long, in the fertile Okanogan Valley, home of some of the finest and most productive fruit orchards in North America. The design employs the same Lombardy poplars that form windbreaks in the surrounding countryside—to orient travelers and provide visual cues about how to proceed. The experience is similar on each side of the border. As cars approach, a row of new columnar trees is visible over the surrounding orchards, signaling the border is near. The road passes through these trees and into an open zone between the first row of trees and another planted along the border. Cars then turn and move parallel to the border to reach the customs booths. The parallel walls of poplars focus the views toward the Cascade Mountain range (for those crossing into Canada) and the lake (for those coming into the United States) as drivers wait in line at the booths. They then turn once more and pass through a third row of trees, marking the end of the process.

The port building, still under construction, will be a 918-foot (280-m) -long two-story bar that straddles the border. The exact programmatic requirements differ between the two countries, but a continuous shed roof runs the length of the building to unify disparate elements. The first level is discontinuous, with lanes of traffic and inspection booths separating the U.S. and Canadian administration buildings as well as their attendant multipurpose buildings. The administration buildings are one-story bars perpendicular to and penetrating the long building.

The second floor is continuous, with bridges across traffic lanes that connect the nonpublic functions as well as the U.S. and Canadian sides of the building. A section of the shed roof is cut at the border and infilled with glass to identify this significant but otherwise invisible line.

For economy and efficiency, the first-floor walls are tilt-up concrete panels like those of the fruit warehouses in the area. The design, a refinement of this straightforward construction system, features modulated panel sizes, extensive windows, and expressive steel connection details. The first-floor walls sit inboard of an exposed steel structure supporting the shed roof. The plus-shaped steel columns have four flanges that allow the building to be physically erected with bolts instead of welding.

BELOW ‖ The essence of the design is the landscaping, which reflects the surrounding orchards and uses trees as a wayfinding device for drivers crossing the border.

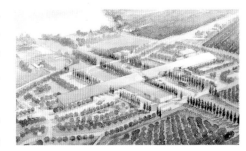

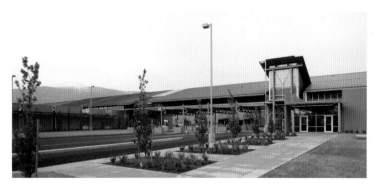

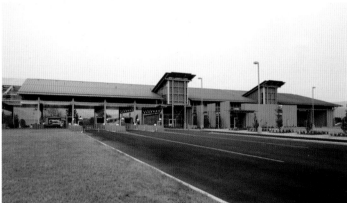

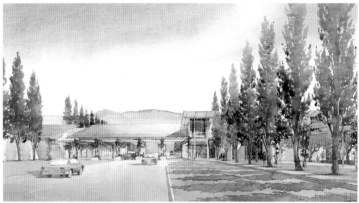

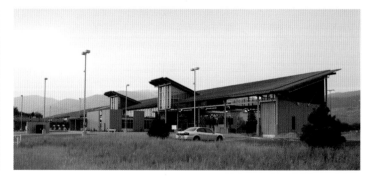

ABOVE ‖ Approaching drivers pass under a continuous shed roof that covers the inspection booths and connects the U.S. and Canadian administration buildings. Glass infills a section of the roof to identify the border.

LEFT ‖ A conceptual sketch shows a steel plate marking the U.S.-Canadian border. At 1,800 miles (2,897 km), it is the longest straight line in the world. The triangular tip of this (unfunded) art project suggests the infinitely small boundary between countries as drivers slow down and pass over it.

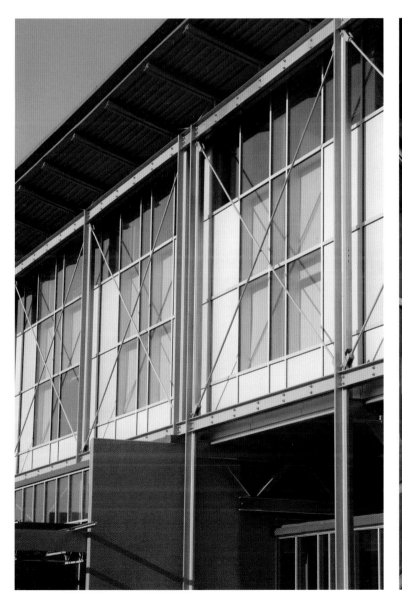

BELOW AND OPPOSITE ‖ The structure combines tilt-up concrete panels, like those of the local fruit warehouses, with exposed steel columns and beams.

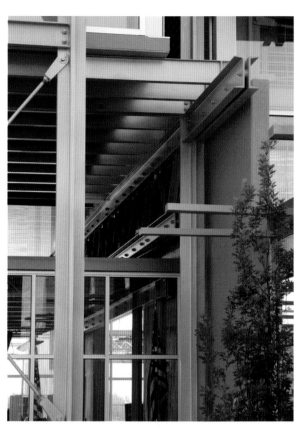

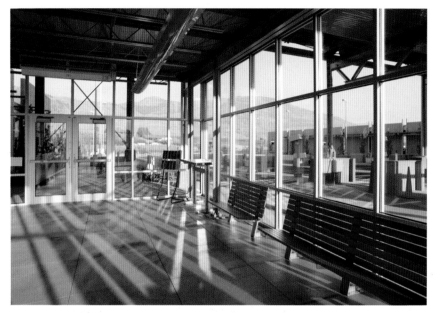

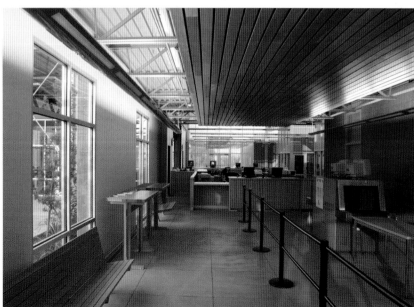

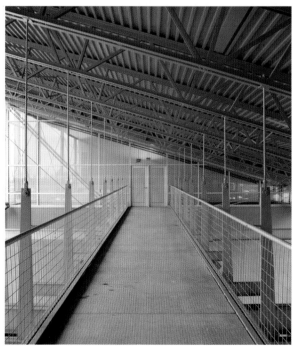

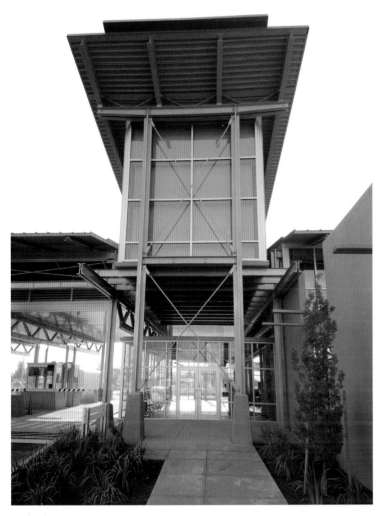

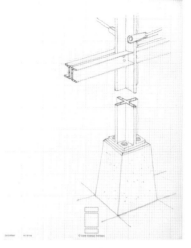

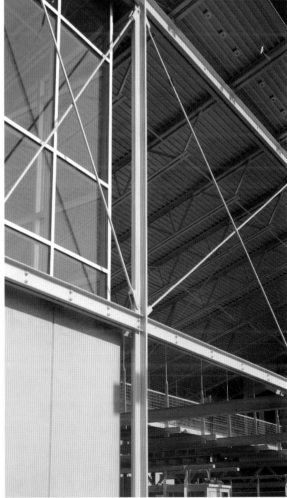

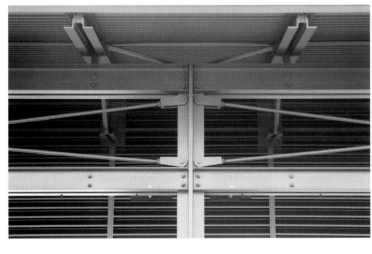

Details: Column Bases
and Capitals

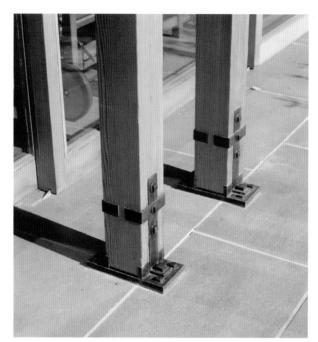

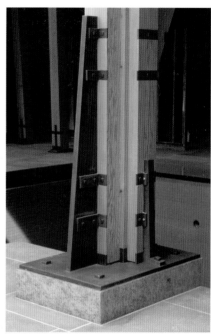

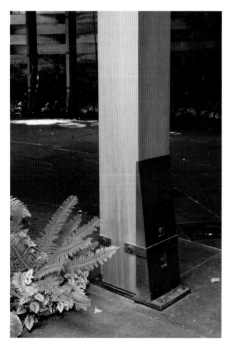

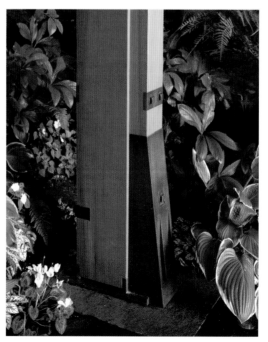

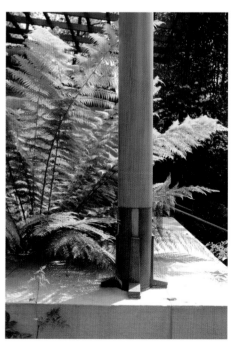

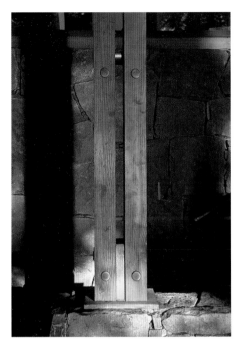
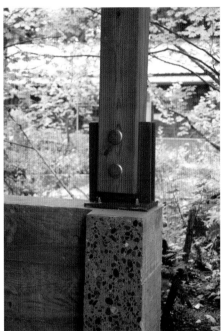
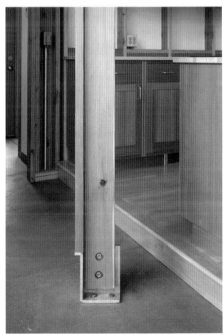
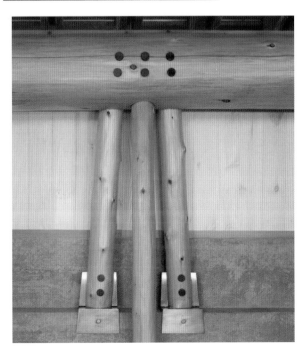

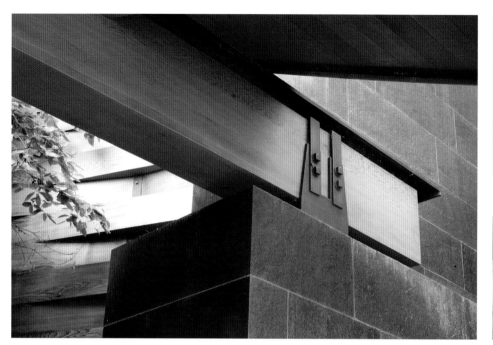
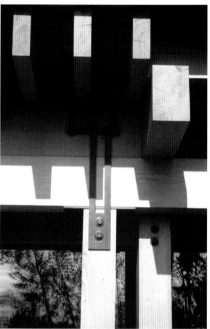
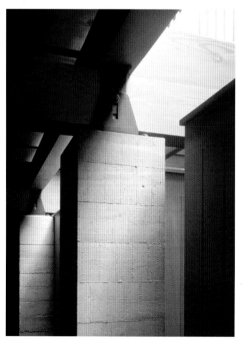
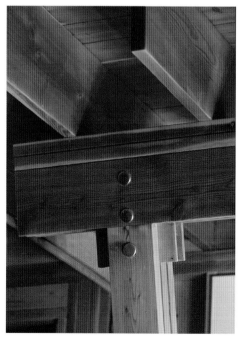
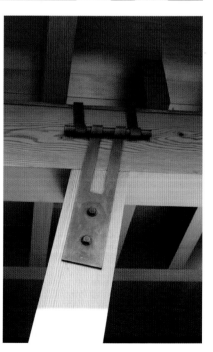

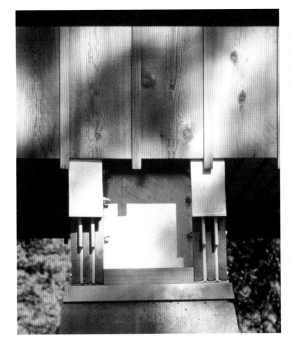
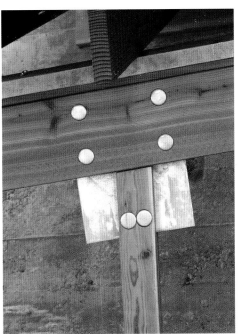
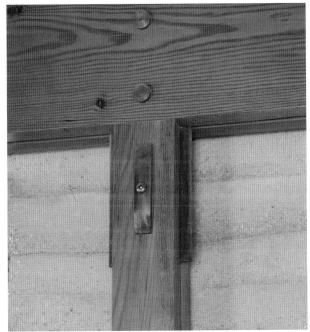
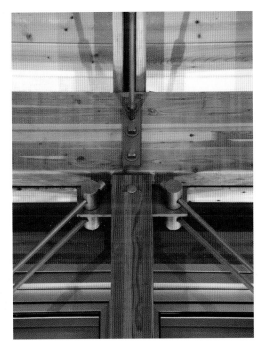

List of Works and Credits

Entry Turnaround, Medina, Washington

(Joint venture with Bohlin Cywinski Jackson)

Client: Private

Project Team: from CAA: Jim Cutler FAIA, Bruce Anderson AIA, Pat Munter, Mark Wettstone; from BCJ: Peter Bohlin, FAIA, Terrence Wagner, AIA, Robert Miller, AIA, Bill Loose, AIA.

Landscape Architect: The Berger Partnership, P.S., Seattle, WA

Structural Engineer: KPFF Consulting Engineers, Seattle, WA

Contractor: Sellen Construction Co., Inc. Seattle, WA

Photographers: Art Grice, Jim Cutler, Bruce Anderson, Karl Backus

Norfolk Armed Forces Memorial, Norfolk, VA

Client: City of Norfolk

Project Team: Jim Cutler, Lee Braun, Maggie Smith, Visual Artist

Landscape Architect: Verdigris Landscape Architects, Seattle, WA

Engineers: URS Consultants, Virginia Beach, VA; MMM Design Group, Norfolk, VA; Mark Anderson, Walla Walla Foundry,

Walla Walla, WA

Contractor: Techon, Inc., Norfolk, VA

Photographers: John Wadsworth, Jim Cutler

Wood Residence, Vashon Island, Washington

Client: Barbara Wood & Bill Schlaer

Project Team: Jim Cutler, David Cinamon AIA, George Houdek

Landscape Architect: Verdigris Landscape Architects, Seattle, WA

Contractor: Pete Crocker

Photographers: Art Grice, Undine Prohl

Tanglefoot, Priest Lake, Idaho

Client: Private

Project Team: Jim Cutler, Lee Braun, David Wagner

Structural Engineer: Craig Lee PE, SE, Coffman Engineers, Spokane, WA

Contractor: Owner, Humble Homes, Moscow, ID

Photographer: Art Grice

Hewitt Residence, Pittwater, Australia

Client: Jonathan Hewitt

Project Team: Jim Cutler, David Wagner

Structural Engineer: Greg Hiatt, Bainbridge Island, WA

Photographer: Anthony Browell, Oki Doki Words and Pictures

Pine Forest Cabin, Methow Valley, Washington

Client: Private

Project Team: Jim Cutler, Bruce Anderson, Russ Hamlet, Joe Hurley, David Cinamon AIA

Structural Engineer: Monte Clark Engineering, Issaquah, WA

Contractor: Bjornsen Construction, Winthrop, WA

Photographer: Art Grice

Columbia River House, Hood River, Oregon

Client: Private

Project Team: Jim Cutler, Bruce Anderson, Julie Cripe AIA, Chad Harding

Structural Engineer: DeAnn Arnholtz SE, Coffman Engineers, Spokane, WA,

Landscape Architect: Steve Koch ASLA, Portland, OR

Contractor: Tim Huberd, Portland, OR

Photographer: Art Grice

Schmidt Residence, Sequim, Washington

Client: Ron and Lila Schmidt

Project Team: Jim Cutler, David Wagner

Stone Mason: Tony Rodhiger, Port Townsend, WA

Contractor: Alford Homes, Poulsbo, Washington

Photographers: Art Grice, John Granen

Reeve Residence, Lopez Island, Washington

Client: Tom and Sally Reeve

Project Team: Jim Cutler, Janet Longenecker, Julie Cripe AIA

Structural Engineer: DeAnn Arnholtz SE, Coffman Engineers, Spokane, WA

Stone Mason: Tony Rodhiger, Port Townsend, WA

Cabinets: Dan Nichols, Kitsap County, WA

Interior Designer: Susan Okamoto, Seattle, WA

Contractor: Russet Construction, Lopez Island, WA

Head Framer: Brett Ackerman, Lopez Island, WA

Photographer: Art Grice

Grace Episcopal Church, Bainbridge Island, Washington

Client: Diocese of Olympia, Olympia, WA and Grace Episcopal Church Congregation

Project Team: Jim Cutler, Bruce Anderson, Pat Munter, Chad Harding, Hiro Kurozumi, Garrett Naylor

Structural Engineer: Greg Hiatt, Bainbridge Island, WA

Civil Engineer: David Browne, Browne Engineering, Bainbridge Island, WA

Accoustical Engineer: Michael R. Yantis & Associates, Seattle, WA

Contractor: Drury Construction Company, Inc., Poulsbo, WA; Marty Sievertson, Project Manager, Mike Patterson, Superintendent

Photographer: Art Grice

Maple Valley Library, Maple Valley, Washington

Client: King County Library System

Project Team: Jim Cutler (principal in charge), Ray Johnston AIA (Johnston Architects, principal in charge), Mark Pevoto, David Cinamon AIA, Project Managers

Structural Engineer: Swenson Say Faget, Seattle, WA

M/E/P Engineers: McGowan Broz Engineers, Bellevue, WA

Civil Engineers: SvR Engineers, Seattle, WA

Arborist: Jim Barbarinis

Roofing Consultant: Ray Wetherholt

Landscape Architect: Swift and Company, Seattle, WA

Lighting Designer: Patrick Tilley, McGowan Broz Engineers, Bellevue, WA

Interior Designer: Nancy Burfiend, NB Design, Seattle, WA

Contractor: R. Miller, Inc., Commercial Contractors, Edmonds, WA

Lonnie Crabtree, Construction Manager

Capitol Hill Library, Seattle, Washington

Client: City of Seattle

Project Team: Jim Cutler (principal in charge), Ray Johnston (principal in charge), Bruce Anderson, Marc Pevoto, Matthew Bissen

Structural Engineer: Swenson, Say Faget, Seattle, WA

Civil Engineer: Rosewater Engineering

M/E/P Engineers: McGowan Broz Engineers, Bellevue, WA

Landscape Architect: Nakano Associates

Interior Design: Nancy Burfiend, NB Design, Seattle, WA

Artist: Iole Allesandrini

General Contractor: Summit Central Construction, Inc, Enumclaw, WA

Long Residence, Orcas Island, Washington

Client: Dixon and Ruthanne Long

Project Team: Jim Cutler, Julie Cripe AIA, Chad Harding

Structural Engineer: De Ann Arnholtz SE, Coffman Engineers, Spokane, WA

Contractor: Alford Homes, Poulsbo, WA

Photographer: Art Grice

Residence at Meteor Vineyards, Napa, California

Client: Private

Project Team: Jim Cutler, Bruce Anderson, Janet Longenecker, Debra Cedeno, Hiro Kurozumi, Webster Wilson, Sam Hanna, David Wagner, Michael McAllister

Structural Engineer: Craig Lee PE, SE & DeAnn Arnholtz SE, Coffman Engineers, Spokane, WA

Vineyard Specialist: Mike Wolf, Vineyard Services, Inc., St. Helena, CA

Contractors: Cello & Maudru Construction Co., Inc., Napa, CA

Photographer: Art Grice

A New Joint Port of Entry, Oroville, Washington, and Osoyoos, British Columbia, Canada

Client: US General Services Administration, Region 10, Auburn, WA; Canada Customs and Revenue Agency, Ottawa, Canada

Project Team: Cutler Anderson Architects: Jim Cutler, Pat Munter; from Bassetti Architects: Rick Huxley, Michael Thorpe, John Jeffcott

Associated Architects: Bassetti Architects, Seattle, WA; Meiklejohn Architects, Penticton, British Columbia, Canada

Landscape Architect: Verdigris Landscape Architects, Seattle, WA

Civil Engineer: White Shield, Inc., Portland, OR

Structural Engineer: KPFF, Seattle, WA

Mechanical Engineer: The Greenbusch Group, Seattle, WA

Electrical Engineer: Interface Engineering, Kirkland, WA

Contractors:

United States side: Intermountain Construction, Inc., Idaho Falls, ID; Derek Wright, Project Manager; Eric Reese, Superintendent

Canadian side: Greyback Construction, Penticton, British Columbia, Canada; Larry Kenyon, Project Manager; Gilber Thore, Superintendent

Photographer: Art Grice

Firm Awards

Design Honor Award 2003
The Interfaith Forum on Religion, Art, and
Architecture and *Faith and Form* Magazine
Grace Episcopal Church

Merit Award 2003
American Institute of Architects/Sunset
Magazine Western Home Awards
The Reeve Residence

Award of Excellence 2003
Building with Trees Awards
Maple Valley Library

U.S. Dept. of Energy
"2003 Energy Saver Showcase"

Honor Award 2002
American Institute of Architects, Seattle Chapter
Reeve Residence

Honor Award 2002
The Wood Design Awards
Reeve Residence

National Honor Award 2001
American Institute of Architects
Maple Valley Library

Honor Award 2001
American Institute of Architects, Seattle Chapter
Maple Valley Library

Honor Award 2001
The Wood Design Awards
Maple Valley Library

Merit Award 2001
American Institute of Architects,
Northwest and Pacific Region
Pine Forest Cabin

Merit Award 2001
The Wood Design Awards
Pine Forest Cabin

Merit Award 2001
American Institute of Architects/Sunset

Magazine Western Home Awards
The Schmidt Residence

National Honor Award 2000
American Institute of Architects
Pine Forest Cabin

Honor Award 2000
American Institute of Architects, Seattle Chapter
Pine Forest Cabin

National Honor Award 1996
American Institute of Architects
A Guesthouse in the Pacific Northwest,
Medina, WA

Merit Award 1995
American Institute of Architects, American
Wood Council
Paulk Residence

Citation 1995
American Institute of Architects/Sunset
Magazine Western Home Awards
Paulk Residence

National Honor Award 1994
American Institute of Architects
Salem Witch Trials Tercentenary Memorial

Honor Award 1994
American Institute of Architects,
Northwest Regional Chapter
Virginia Merrill Bloedel Education Center

Honor Award 1994
American Institute of Architects, Seattle Chapter
Paulk Residence

Award of Excellence 1994
American Institute of Architects/Western Red
Cedar Association
Paulk Residence

National Honor Award 1993
American Institute of Architects
Virginia Merrill Bloedel Education Center

Honor Award 1993
American Institute of Architects, Seattle Chapter
Salem Witch Trials Tercentenary Memorial

Honor Award 1993
Boston Society of Architects
Salem Witch Trials Tercentenary Memorial

Honor Award 1992
American Institute of Architects, Seattle Chapter
Virginia Merrill Bloedel Education Center

Honor Award 1992
American Institute of Architects/American
Wood Council
Virginia Merrill Bloedel Education Center

Citation 1991
American Institute of Architects/Sunset
Magazine Western Home Awards
The Bridge House

Award of Merit 1989
American Institute of Architects/American
Wood Council
The Bridge House

Merit Award 1989
American Institute of Architects/Western Red
Cedar Association
The Bridge House

Honor Award 1988
American Institute of Architects, Seattle Chapter
Wright Guest House

Award of Merit 1988
American Institute of Architects/American
Wood Council
Wright Guest House

Merit Award 1987
American Institute of Architects/Western Red
Cedar Association
Strickland Residence

Award of Merit 1987
American Institute of Architects/Sunset

Biographies

James L. Cutler, FAIA, was born in 1949 in Wilkes-Barre, Pennsylvania. He earned a bachelor of arts (1971) and a master's in architecture (1973) at the University of Pennsylvania and earned a second master's in architecture from the Louis I. Kahn Studio Program (1974). He received a Dale Fellowship (a traveling fellowship for design excellence), the James Smythe Turner Prize, and the Edward Spayed Brooke Medal.

Since 1977, he has been principal of his own design firm, Cutler Anderson Architects (formerly James Cutler Architects), on Bainbridge Island, Washington. He served as a critic and design instructor at the universities of Washington, Pennsylvania, and California at Berkeley (Friedman Professorship, 1999) and at Harvard University's Graduate School of Design, and was the Pietro Belluschi Distinguished Visiting Professor at the University of Oregon (1999). The firm's work has been published internationally in books and magazines ranging from *Architectural Record* to *Newsweek* and has won over forty design awards, including six National Honor Awards from the American Institute of Architects.

Bruce E. Anderson, AIA, was born in 1959 in Seattle, Washington. He earned a bachelor of arts (1981) and a master's in architecture (1988) from the University of Washington, where he also received the Architecture Faculty Design Medal and was elected to Tau Sigma Delta Architecture Honor Society. He began working with James Cutler in 1982 and became a partner in 2001. He has served as a critic and instructor at the University of Washington, as chair of the City of Bainbridge Island Planning Commission, and as president of the

Bainbridge Island Land Trust, a nonprofit corporation that has protected over 1,000 acres of wildlife habitat.

Sheri Olson, AIA, is *Architectural Record*'s Seattle-based contributing editor, the architecture columnist for the Seattle Post-*Intelligencer*, and the author of *Miller/Hull: Architects of the Pacific Northwest*.

photographer: Mabe Roche

ABOVE || Cutler Anderson Architects: (L to R) Hiro Kurozumi, Bruce Andreson, Susan Valentine, Jim Cutler, Mollie Farley, Vikki Anderson, Chad Harding, Janet Longenecker, Webster Wilson, Pat Munter, Debra Cedeno, Alan Dodson, Alivia Owens.

Acknowledgments

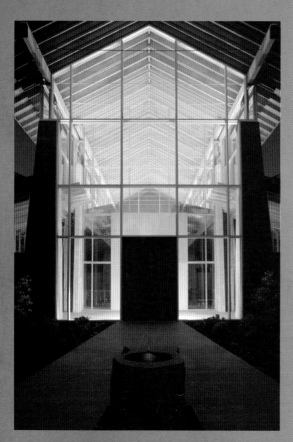

It is difficult to acknowledge the people who in so many ways affected this book and all of the work depicted in it.

The book's publication itself can be credited to the tireless effort of Vikki Anderson, the skilled eye of my long time friend Art Grice, and the clear writing of Sheri Olson.

The work exhibited is the result of the conscientious effort of the whole of this office. None of the projects could have achieved the quality shown without each person doing their part, from the clerical staff to my partners.

Everyone truly believes in the work that we do and I feel it could not have been achieved without all of us working together.

The clients who funded the execution of this work have exhibited a faith in this firm of which we have often felt unworthy. Many times we have delayed or changed the work to get things "just right." And invariably our clients have supported and encouraged us to explore and refine the design to its fullest extent.

The contractors who executed the work very often struggled with the complex effort that it takes to make things look "simple." I have worked with one of these firms for over twenty years and have watched with delight as Butch Alford has grown to the point where he is very often suggesting excellent improvements to the work. I'm gratified by the sense of achievement that each contractor has exhibited when they master our direct but sometimes complex language.

Finally, there are my friends and family: my good friend Gary Bonzon, who helped me through the hardest years of my life. My three daughters, Jessie, Eliza, and Lucy, who endured my frequent business trips, my late nights at my desk, and my stunningly bad cooking. And my wife Beth Wheeler, whose patient support has brought a calmness to my life, which I have not known for a decade.

—Jim Cutler

Our work represents the collaboration between our clients, the builders, and ourselves. Our best work happens when our clients' aspirations and support combine with a builder's striving for perfection with an enthusiastic crew.

In our firm, our hardworking staff is necessary to accomplish what we do. We don't thank them enough.

I want to thank Vikki Anderson for her constant support, understanding, and patience, not to mention her efforts at making this book happen. Also our children, who are growing up thinking it is normal for architecture to be important.

—Bruce Anderson

Thanks to Mary Ann Hall and Winnie Prentiss at Rockport Publishers; special thanks to Jim Cutler, Bruce Anderson, Vikki Anderson, and Mollie Farley; and heartfelt thanks to Phil and Owen Klinkon.

—Sheri Olson